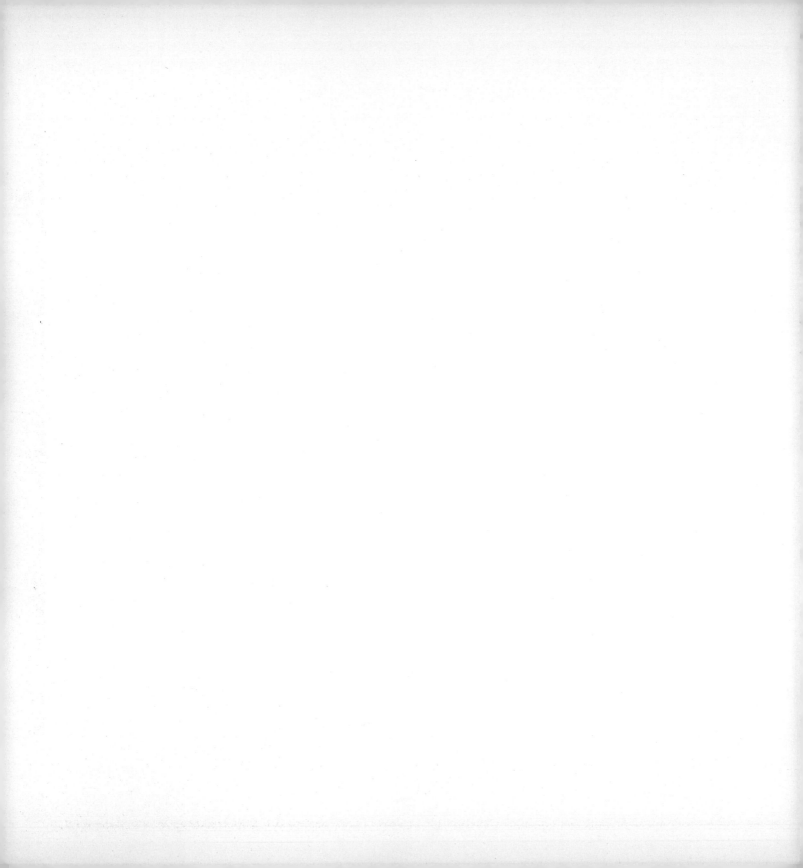

BEVERLY MASSACHUSETTS

QUARRY BOOKS

painted
pages

* * *

fueling creativity
with sketchbooks
& mixed media

by sarah ahearn bellemare

photography by thea coughlin

First published in the United States of America in 2011 by
Quarry Books, a member of
Quayside Publishing Group
100 Cummings Center
Suite 406-L
Beverly, Massachusetts 01915-6101
Telephone: (978) 282-9590
Fax: (978) 283-2742
www.quarrybooks.com
Visit www.Craftside.Typepad.com for a behind-the-scenes peek at our crafty world!

10 9 8 7 6 5 4 3 2 1

ISBN-13: 978-1-59253-686-3
ISBN-10: 1-59253-686-7

Digital edition published in 2011
eISBN-13: 978-1-61058-017-5

Library of Congress Cataloging-in-Publication Data

Ahearn Bellemare, Sarah.
 Painted Pages : Fueling Creativity with Sketchbooks and Mixed Media
 / Sarah Ahearn Bellemare.
 pages cm
 ISBN-13: 978-1-59253-686-3
 ISBN-10: 1-59253-686-7
 1. Art--Technique. 2. Notebooks. I. Title.
 N7430.5.B45 2011
 702.8--dc22

2010047133
CIP

Design: everlution design
All artwork by Sarah Ahearn Bellemare, unless otherwise indicated.

Printed in China

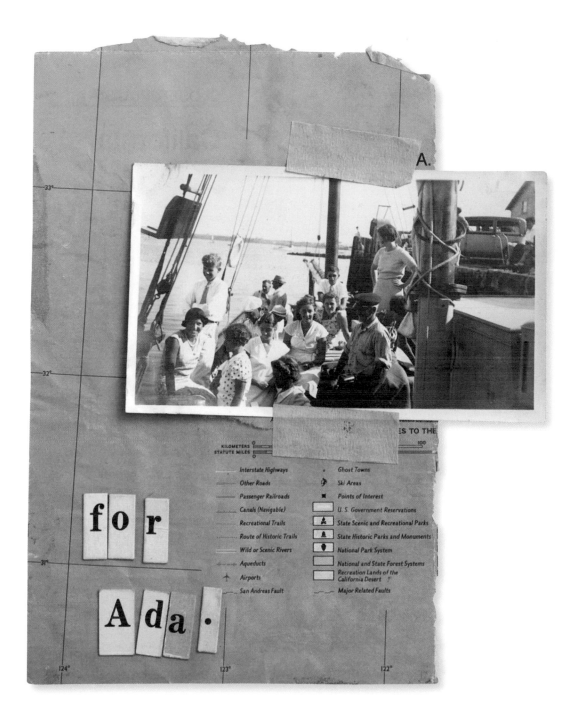

introduction * * *

This is a book about finding your way, your own way, in the everyday, to be creative and make art. You'll notice that this is not your typical how-to book. Instead of showing you continual step-by-step instructions, I am simply giving you a nudge to start down, or continue on, your own creative path. The way you ultimately go is up to you, as your creative passions may lead you in many directions, but I hope that showing you where mine have taken me will encourage you to continue your own journey. In this book, you'll get an insider's view into my workspace, sketchbooks, and creative process. In addition, you'll see how I use my favorite materials, alongside a variety of useful tricks and tips for art making.

We'll start in a sketchbook, where you'll have a place to explore, play, and make mistakes—all fundamental parts of the creative process. I'll then guide you through some ways of using the work you've created beyond your sketchbook to inspire you in large-scale mixed-media paintings. At the end of each chapter we'll also visit the studios and sketchbooks of some of my artistic friends. They'll give us a glimpse of their artwork and a behind-the-scenes look into their creative process.

Most important, I hope this book will help you recognize and develop your own artistic style. Listen to your inner voice and let that be your guide as you create. There are no wrong turns to take if you stay true to your vision. Discover the beauty in the everyday, as you look around to find your own stories to explore and capture in paint.

-sarah

" Art washes away from the soul the dust of everyday life. "

—PICASSO

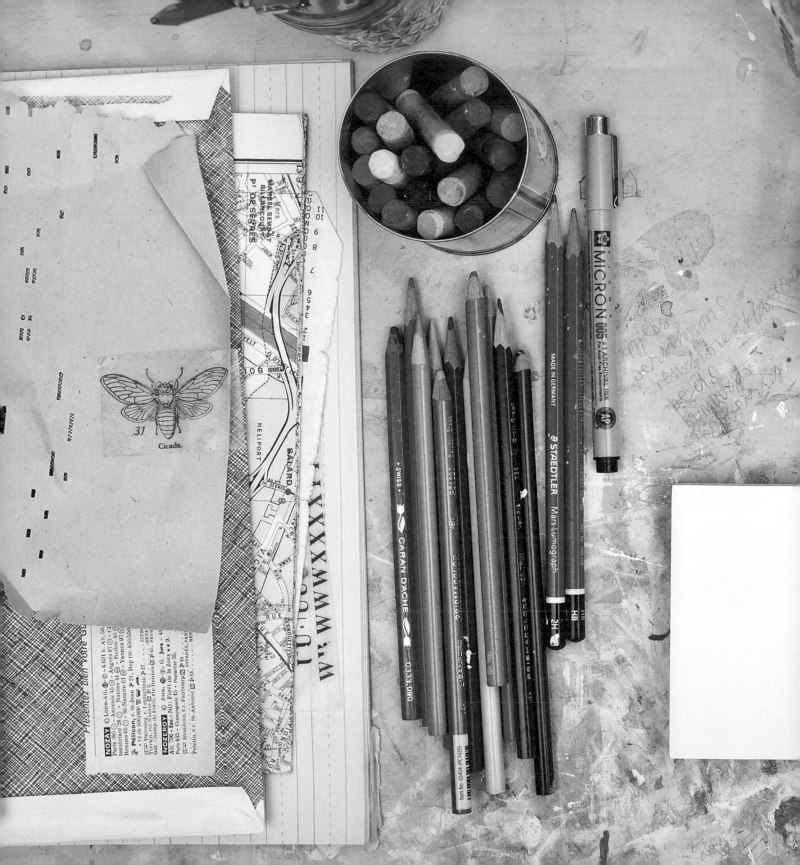

chapter one:
starting out

materials to gather ›

Like many artists, I'm a kid in a candy store when I'm in an art supply shop; I just love all the colors and scents and the array of tools and possibilities to choose from!

Here you'll find a list of my tried-and-true supplies—the ones I am always sure to have on hand when I'm working. To get you started, I've included a description of why I like each item and how I use it. Be sure to play around and choose for yourself how you might like to use them too. For example, you might like a thicker consistency in your paint or a fatter brush for your own work. I encourage you to discover your own favorite supplies and ways of working, since there's really no wrong or right way to explore in mixed media!

You'll see that I divide my supplies into four categories: dry, wet, tools, and fun extras. I try to stay organized by keeping the wet supplies on the right-hand side of my desk and the dry materials on the left. The paints and brushes are easily accessible on the right, as I'm right-handed, but it's also important to keep wet and dry separated. I've learned the hard way that nothing is worse than spilling a jar of dirty paint water on your box of special collage papers.

In the tools category, you'll find items I consider must-haves, while the fun extras are just that—some little things I've discovered that add joy to the art-making process.

favorite art supplies: dry

a) painting surfaces
Try gesso boards as a surface for your mixed-media paintings. The surface is pre-primed and sanded smooth, and most important, it's acid-free. I sometimes paint on canvas when I work large, but gesso boards are a wonderful surface for small collages and mixed-media pieces. There are many different of types of surfaces to try, so experiment to see what you like best.

b) pens
Have an acid-free pen for signing your work. Black Micron pens work well. Keep a supply of different widths to choose from. This is an important point to reiterate: Sign your work! You are an artist!

c) chalk (soft) pastels
Soft pastels are fun to work with on gesso boards. Use them directly on the board, then try smudging with your finger, spraying lightly with water, or covering with a coat of gel medium and see what happens.

d) colored pencils
Prismacolor brand pencils make nice bright lines with good pigment. Try drawing with the pencils directly onto your board, or on top of dried paint and collage material. You'll also use these as an easy way to add color to your sketchbook.

e) ruler
It's always good to have one on hand for drawing straight lines.

f) artist pencils
Staedtler brand artist pencils are available in a variety of hard and soft versions. Outline shapes or write directly on the board with the pencils.

Collage materials galore!

Some favorite collage items include maps, graph paper, cut-up pages from books, and security envelopes.

It's easy to add the collage papers to your painting. To apply, simply paint a thin layer of gel medium onto the board, and then gently press down your piece of collage paper. Smooth with your fingers at first, then paint another layer or two of gel medium with your brush and continue to smooth while pressing down. Add one or more topcoats of medium when dry, making sure your layers of medium are even to help prevent the papers from bubbling up. The topcoat will act as a sealant to protect vintage or non-acid-free papers from fading over time.

favorite art supplies: wet

(a) paint

Golden brand heavy-body acrylics are my paint of choice. I tend to water down my paints and use them more like a watercolor because I like the fluid consistency. Acrylic paints are very versatile; I sometimes use the color directly out of the jar when I want a thicker coat. Try playing with the consistency of the paint on your palette to see what works best for you.

(b) gel medium

Think of gel medium as your glue. I swear by Golden brand Semi-Gloss with a UV filter. The gel brushes on clear and dries with a nice finish that's not too shiny. It protects the collage pieces from fading and seals everything beautifully. To use, simply brush a layer onto your painting surface and your collage papers. Also use a top coat or two to seal and protect your delicate collage papers from fading once they are placed on your painting. You can choose from many different types of gel mediums, but this one is my favorite by far. Experiment to find the gel that works best for you.

(c) gesso

Gesso is a primer. Use it to add texture, or tooth, to the very smooth surface of the gesso boards. It's not always necessary, and I find that I am not partial to a certain brand. To use, brush on the gesso as you would paint and let it fully dry before you begin.

d brushes

My advice: Don't buy fancy, expensive brushes. If you are anything like me, you'll inevitably end up leaving them in the dirty water and forget to wash them on a regular basis. (Perhaps I picked up this habit because one of my first jobs was as a studio assistant to an artist whose brushes it was my duty to wash when she went out to lunch!)

In general, for bigger-size brushes, I like a short, wooden handle with flat, stiff bristles. For small brushes, simple plastic-handled, softer brushes work just fine for me. Be sure to have lots of different sizes to choose from as you work. Experiment and find out what might feel and work best for you.

e jars for water and brushes

I try to recycle and reuse whenever possible, so I like to keep my brushes and water in old glass jars. Glass jars are heavy, so they are less likely to tip over when full, and they also allow you to see when it's time to get clean water.

Do your best to change the water often and keep it clean. It helps keep your colors from getting muddy.

f aprons

I have turned far too many of my favorite clothes into "painting" clothes by not wearing an apron! I never fail to get paint on myself when I'm working, so I highly recommend always wearing an apron. I have a full-size and a half-size apron that I keep hanging on the back of my chair so I don't forget to tie one on before I get to work.

g towels/rags

I use rags or hand-size (cheap, white) bath towels. I keep one in my lap and use it to clean up spills or wipe off brushes with excess paint, as well as my hands.

h palette or tray for paint mixing

A small metal tray can be used over and over again until it has become art itself. Recently I've been using a pad of palette paper. Sometimes I save palettes and hang them on my wall as color inspiration.

i small spray bottle

Acrylic paints dry quite quickly. In many ways, this is an advantage. However, it's important to always keep the paint on your tray or palette wet. That's where the spray bottle comes in. It's no fun mixing the perfect color only to find that it's dried out while you've stepped away for a snack or break. Constantly spray down the palette as you work. The spray bottle will come in handy if you ever need to "erase" some paint that hasn't quite dried from your floor or clothes! You can also spray down your palette, wrap it in plastic wrap, and save it for another day.

In addition, you'll want to have the spray bottle on hand for the image transfer technique described in chapter 4.

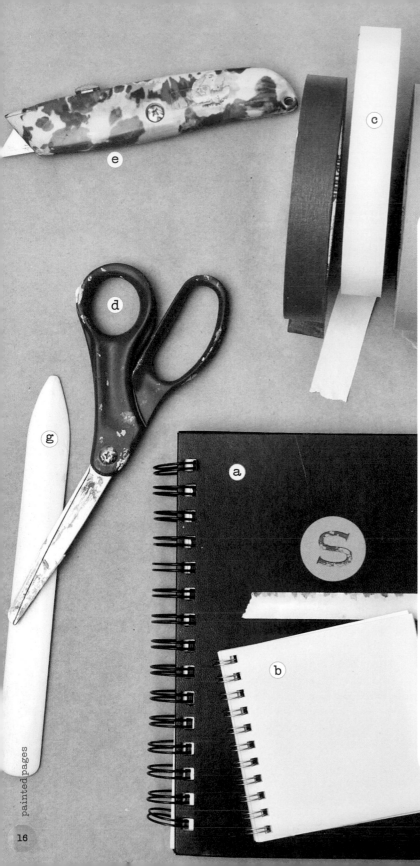

TOOLS

must have tools

(a) a sketchbook
A 5" x 7" (13 x 18 cm) hardcover, spiral-bound sketch-book is a great size to take along with you wherever you go. My favorite brand is Pro-Art, which is acid-free and very affordable.

(b) a smaller sketchbook
This little book is used as a "scrap book," which you can read about in chapter 2.

(c) a roll of masking or artist tape
Masking tape is great for taping off a section of a painting or using as a ruler to draw a straight line. It's not overly sticky, so it won't leave a residue.

(d) scissors
Keep a big and a small pair on hand for cutting up collage papers.

(e) a craft knife
This tool can be helpful for cutting tiny pieces of paper or cutting out intricate shapes.

(f) a roll or two of clear contact paper
This will be needed for the contact paper transfers detailed in chapter 4. I like to have a thin roll and a thick roll on hand. Make sure that they are both acid-free.

(g) bone folder
Bone folders help ensure a crisp fold and are used as a burnishing tool with transfer techniques.

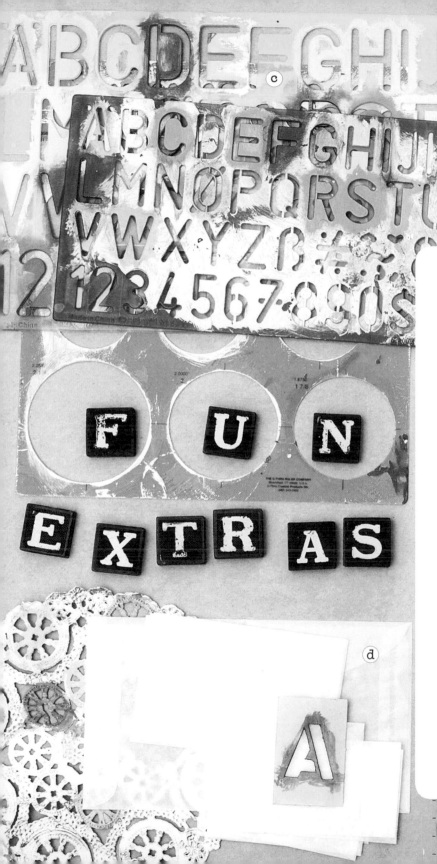

fun extras

(a) letter and number rubber stamps

Keep on hand a variety of letter and number stamps that you don't mind using with paint. I don't use the stamps with inkpads; instead, for the "ink" I stamp them into thin layers of paint on my palette. Use your spray bottle to clean off the stamps right away; if you don't wet and wipe off the paint after you are done with the stamp, it will become caked with dried paint.

(b) rub-on letter sheets

These are my favorites! I was given a huge stash of these vintage sheets years ago and I just love them. They are easy to use on gesso boards; just rub them onto the board with a pencil. If you make a mistake, grab your craft knife and peel or scrape them off. When you have your letters as you want them, I recommend adding a layer of gel medium over the top to seal them in place. Sheets of letters and numbers like these can be found at office supply stores.

(c) stencils

Use plastic stencils to add fun shapes, letters, and numbers to your painting. Use a fat, stiff brush with just a little bit of paint—a dabbing motion will do the trick.

(d) glassine envelopes

Oooh la la, I just love glassine envelopes! Glue or tape these adorable envelopes in your sketchbooks to hold little special bits of ephemera, collage, notes, or photographs.

warm-up activity:
two-minute prompts

........

Feeling daunted by trying out new-to-you materials? Here are some easy and fun tricks to get you started!

These "two-minute prompt" exercises are a sort of musical chairs–style game you can play on your own at home as a warm-up for an art-making session. The prompts will help get you familiar with the materials; you'll be surprised what might emerge on your canvas after just two minutes.

Here's how the process works; try it out for yourself!

try it out!

YOU'LL NEED

~ prompt cards on page 128 of this book; photocopy and cut out

~ a bowl in which to put the prompt cards

~ a timer you can set (and then easily reset) for two minutes

~ a small gesso board (8" x 8" [20 x 20 cm] or smaller)

~ all of your art supplies ready to go in front of you

THE RULES

• Set your timer for two minutes only.

• Without looking, choose one of the prompts from the bowl and follow the direction.

• Don't overthink what you are doing; just clear your mind and play.

• Do not worry about the final outcome; think of this as a fun practice session.

• Take the full time to experiment with the material.

• As soon as the two minutes are up, stop!

Repeat the above steps on the same board with four more prompts, allowing just two minutes with each card. Total time for this warm-up exercise is just ten minutes, but you'll be surprised by what you create in that time without even realizing it. You'll have a great start to a new little masterpiece and a new appreciation and understanding of your materials.

here's how it works:

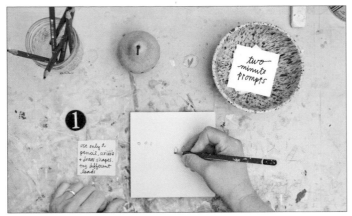

step one: Using only a pencil, simply draw shapes, scribbles, or outlines. Try different leads of artist pencils along with regular pencils.

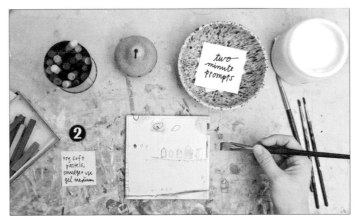

step two: Try out soft chalk pastels and smudge with your finger on the board. Layer a coat of gel medium over a section to see how the color changes.

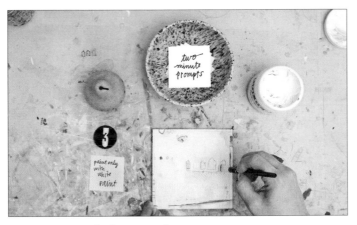

step three: Paint with white paint only.

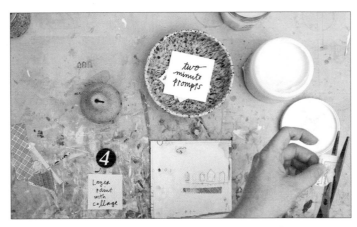

step four: Layer paint with collage. (In other words, don't keep them separate; try layering one on top of the other.)

step five: Write something with the rub-on letters. (You'll need a pencil for burnishing.)

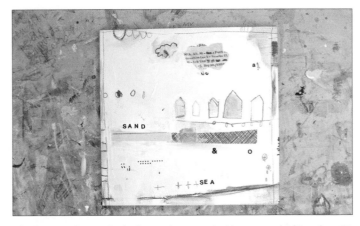

After just ten minutes, look what you've created without even thinking about it!

how to begin

Now that you've warmed up with the two-minute prompts, let's look at some other ways to begin a new piece. Two of the questions I get asked most frequently about my work are how I choose my colors and how I decide on the composition for a piece. On the following pages, I've outlined some ways to help you learn to be comfortable with and explore color and composition in your own work.

mere color, unspoiled by meaning, and unallied with definite form, can speak to the soul in a thousand ways

— oscar wilde

A favorite quote from Oscar Wilde alongside brand new chalk pastels.

color

Be sure to experiment with a wide variety of colors, not just the ones you are drawn to. When I first started painting, I used a lot of blues; Picasso wasn't the only one with a "blue period." One day, I accidentally dropped a dash of red next to a greenish blue on my canvas. The red really made that blue "pop" right out! It was an important learning moment when I realized that the colors I'd been "afraid" of weren't so bad after all.

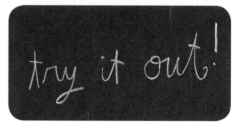

PLAY WITH COLOR!

I don't have a special secret formula that will tell you how to choose colors. I simply paint with colors I love and try to just go with my instincts as I work. Make yourself do the same.

~ Don't over-think your use of color.

~ Play and see what is pleasing to your eye.

~ Find colors that speak to you and put them next to each other.

~ Test them out.

~ Experiment. Have fun. Explore.

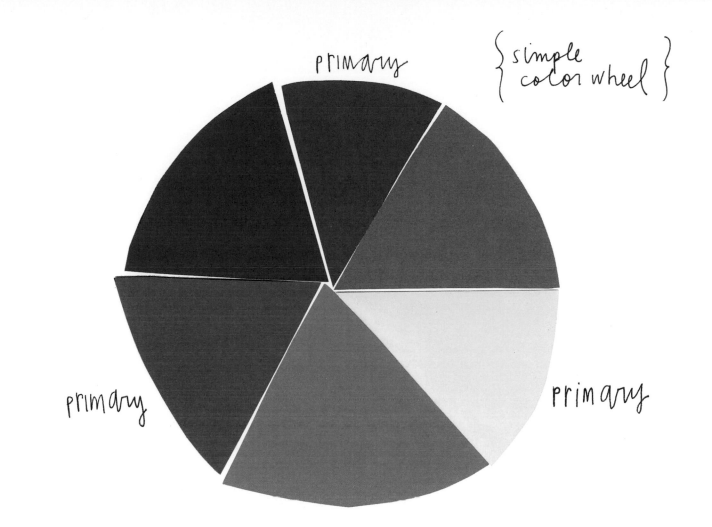

primary

{ simple color wheel }

primary

primary

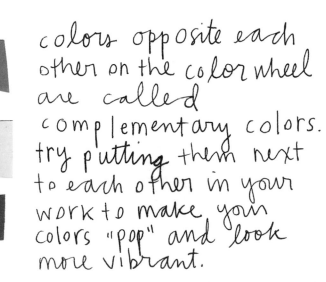

colors opposite each other on the color wheel are called complementary colors. try putting them next to each other in your work to make your colors "pop" and look more vibrant.

primary colors make all other colors.

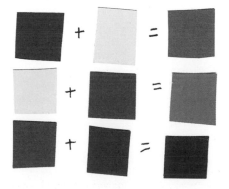

composition: playing with details

Here's a fun way to try out different compositions. I happened upon this method by accident when I first started using Photoshop. I zoomed in on a scan of one of my paintings and stumbled on a fantastic little composition in the corner of a larger image. The new image contained elements of the larger painting but had a level of simplicity that I probably wouldn't have created if starting out with a blank canvas. The new composition was so inspiring that I then cropped and saved this small detail as its own little piece.

You'll often be amazed by what you find hidden in your own work.

Beautiful compositions you unknowingly create are waiting to be discovered.

Follow these steps to try this technique on your own:

- Scan some of your own paintings.

- Open an image of a painting or collage in Photoshop or in another photo editing program.

- Zoom in on different parts of your image and scroll around to find a little landscape or composition that you really like.

- Crop and remember to save as a new image.

- Keep for reference in a details file or print a few out to keep in your sketchbook for inspiration when you are stuck.

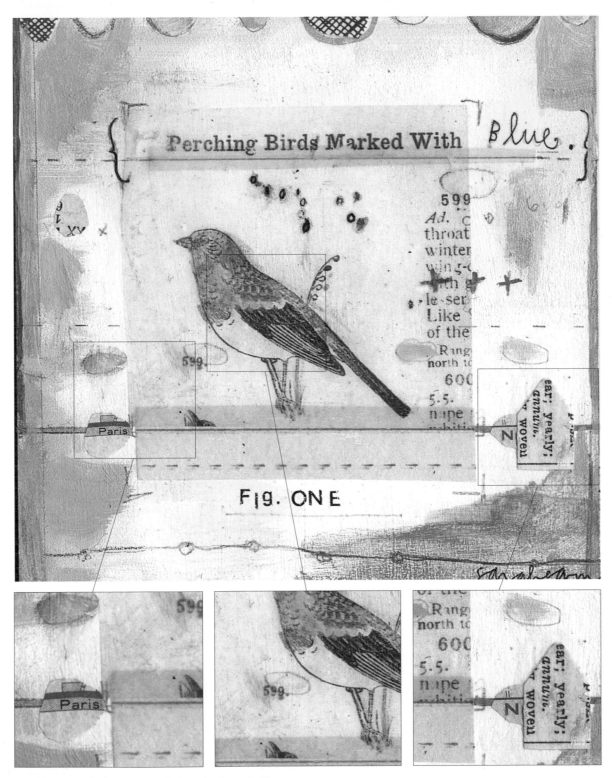

Here you see one large painting with three detail compositions.

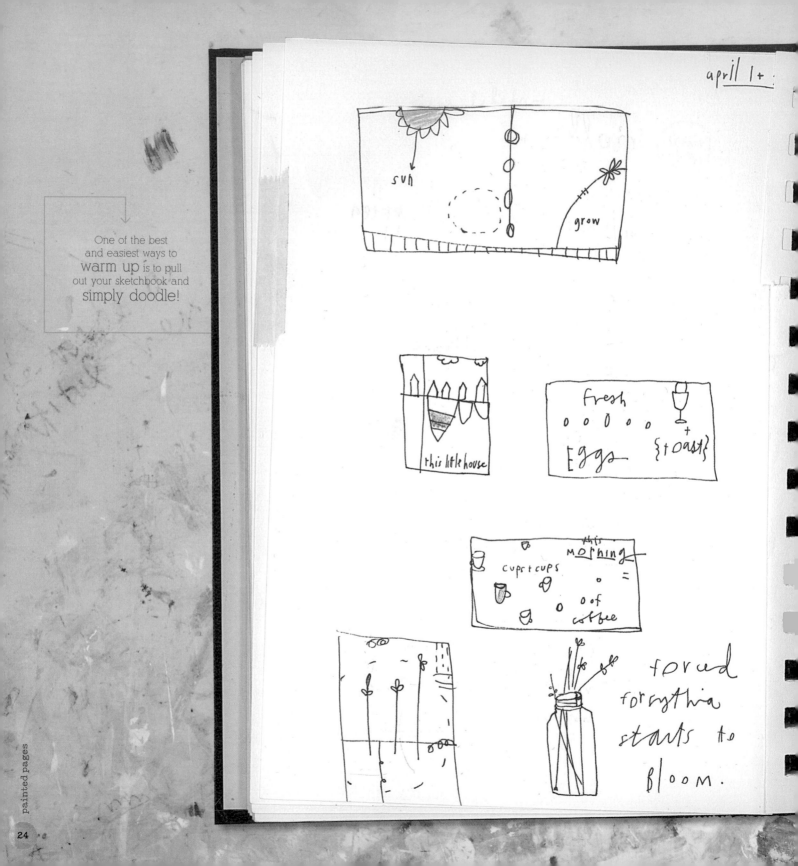

One of the best and easiest ways to **warm up** is to pull out your sketchbook and **simply doodle!**

april 1+

sun

grow

this little house

fresh
o o o o o
Eggs {toast}

this
morning
cups+cups

o =
o o of
coffee

forced
forsythia
starts to
bloom.

STUDIES—

blossoms

home

Round + Round
ooo.

*

strawberry

fresheggs

jars
+ jars of
fresh jam.

1 2 3

a blanket of stars

goat.

At the end of each chapter throughout the book you will find some words and pictures from some of my artist/crafter/writer friends. I've asked them to share a little bit about their creative process. I think you'll like what they have to say!

<table>
<tr><td>

GUEST ARTISTS

</td><td>

Lucie Summers and Heather Smith Jones
> *sketchbook peeks*

</td></tr>
</table>

LUCIE SUMMERS is a mixed-media artist who lives in the English countryside. Lucie designs and prints her own colorful textiles and fun fabrics. When I asked Lucie about sharing her sketchbook, she said she had never been good at keeping one, not even in art school where it was really important. She just got nervous looking at a blank page and feeling that everything had to be perfect. But now, after fifteen years, she feels she is finally getting the hang of it. In her sketchbook, she writes lists, scribbles ideas, and tries not to be too precious. She works directly in a small, soft-backed book with a black fiber-tipped pen. She likes to use a collection of various nib sizes.

At the front of her book are ideas for textile prints, lots of drawings of flowers and leaves, and random shapes and lines. She turns the book upside down and goes to the back to write ideas she needs to get down on paper (before she completely forgets them) under the heading "Randoms." (At the last look-through, there were several notes for using printed felt, quilts, and print design ideas on various materials.) This really helps when she's stuck for inspiration. She's even found that ideas can be sparked from a quick flick-through. She considers it less a sketchbook and more an idea book.

HEATHER SMITH JONES is a watercolor painter and arts instructor who lives and works in Kansas. I asked Heather to share a "sneak peek" into her sketchbook and to tell us how keeping one fits into her art-making routine. She said that keeping a sketchbook is an integral part of her creative process. In it, she draws new ideas, gathers ephemera or moments from daily life, and records thoughts about her work. It is a place to catch ideas, which can happen spontaneously, and to write and draw without hesitation. Sometimes she incorporates things such as leaves or plants with colors or shapes that are inspiring and small sketches drawn on other paper. Together, all these elements form a collection of ideas. An important aspect of the entire process is taking time to write in her sketchbook. Writing gives Heather incentive to pause and reflect and to clarify concepts about work in progress.

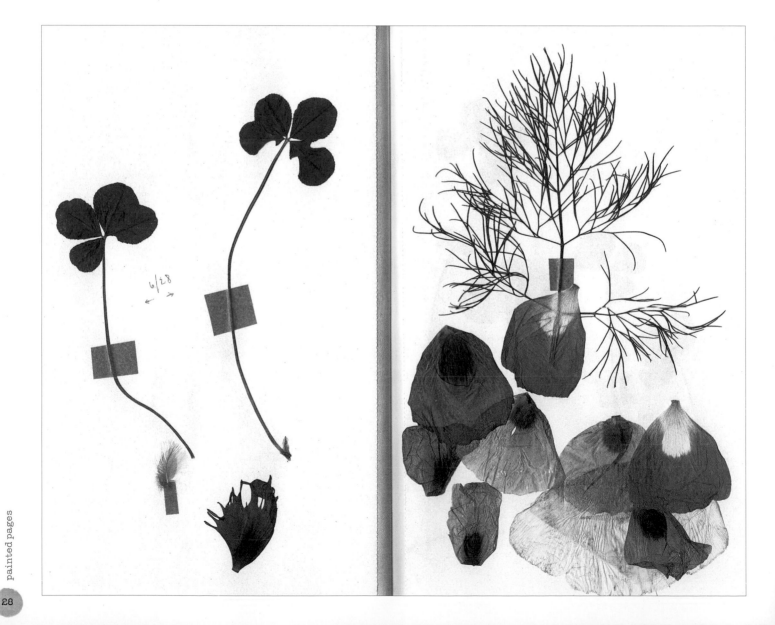

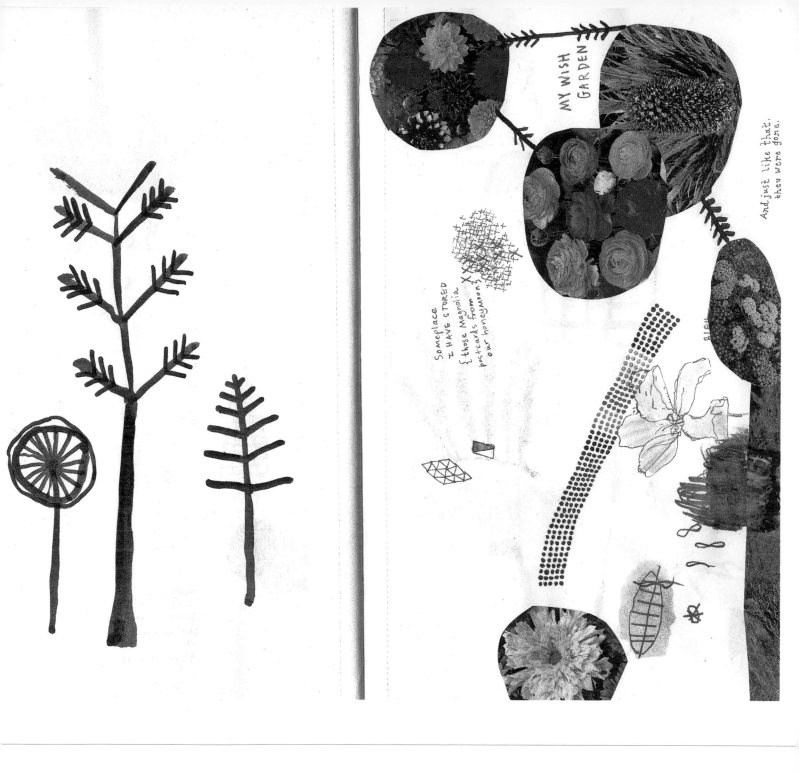

MY WISH GARDEN

And just like that, they were gone.

Someplace I HAVE STORED { those Magnolia postcards from our honeymoon }

BLEU

chapter two:
seek it out

finding inspiration ›

In this chapter, I'll walk you through my studio space and share some of the tricks and techniques I use in the beginning stages of my creative process.

I'll show you my mini "scrap books" (not your typical scrapbook!) filled with instant "scrap" collages—my favorite way to warm up for an art-making session.

From the small scrap books, we'll move into sketchbooks, where I'll show you some ways to work through ideas and compositions. You'll see how you can use your sketchbook as a way to prepare for final, mixed-media paintings.

I'll also share with you some of my favorite ways to find inspiration and get the creative juices flowing.

creative surroundings

It's easy to find inspiration when it's all around you. When I work, I surround myself with lots of little things I love. The large board you see in the photograph at right is a simple store-bought bulletin board that I've covered in a favorite fabric. The fabric is tacked up with map pins, so it's easy to change out when the mood strikes.

Whether it's a ticket stub from a fun excursion, an old family photograph, or a favorite quote scribbled on piece of scrap paper, these little bits of ephemera each have a special story to tell. Their stories act as wonderful inspirations for my sketchbook pages and mixed-media paintings. All the bits and pieces on display above my worktable spark new ideas and help to jump-start my creative process.

It's important to create a workspace that you love to be in. Whether you have a dedicated space for art making, or just a small corner of your home, try to make it your own. It's about making a space that you will love to be in, and once you do, I guarantee that the creative ideas will flow.

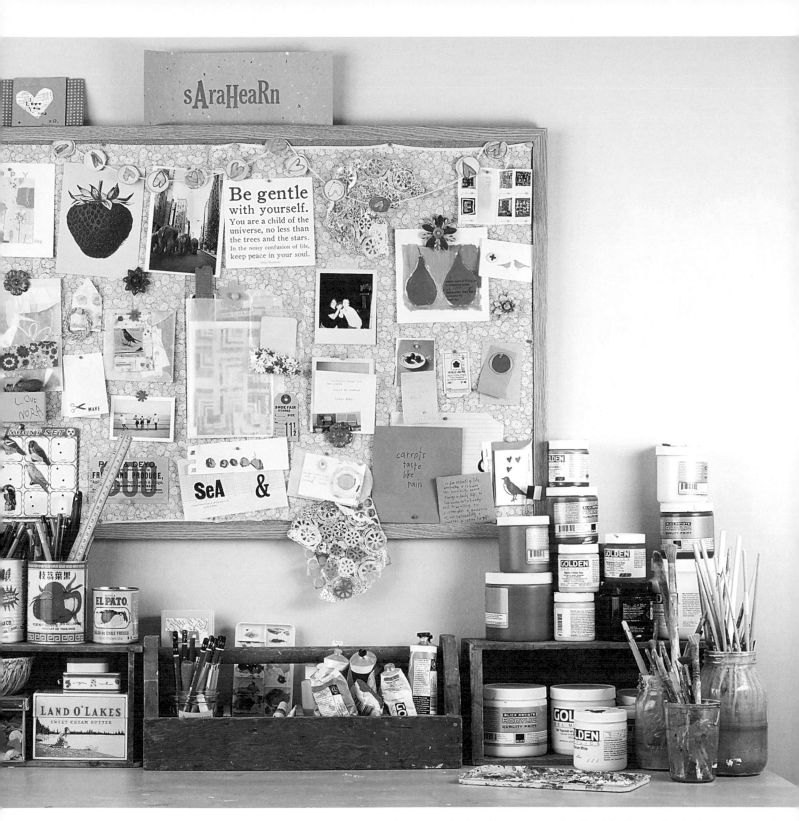

Above my studio worktable is a large inspiration board I use as a giant sketchbook for ideas and inspirations.

My worktable holds only the necessities for an art-making session at an arm's reach.
Colored pencils and tools are contained in fun, colorful (and cheap) tin cans from the supermarket.
Leftover and loose collage papers are always saved and stashed away in colorful boxes and vintage tins.

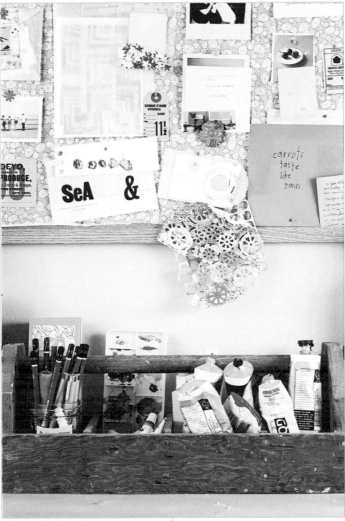

My tubes of paints are held in an antique tool caddy that belonged to my great-grandfather.

Paints are stacked neatly alongside old jelly jars that hold water and paintbrushes.

When I am creating, I am like a sponge; I soak up the colors, textures, and memories of the special little things that surround me. These treasures constantly inform my work and continue to be an endless source of inspiration.

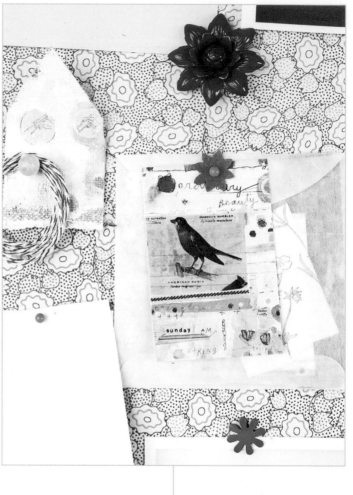

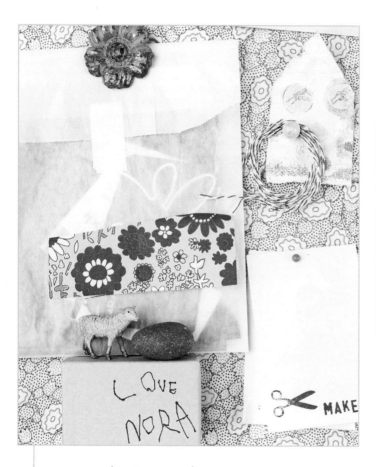

A little house shape cut out of canvas and painted

* * *

One of my bird business cards held up
with a felt flower and map pin

*

Another antique-flower curtain tieback
adds a bright pop of color.

A glassine envelope holds favorite
little cards and clippings.

* * *

A box with a five-year-old's handwriting
is a reminder to stay playful with my work.

* * *

Bakery twine awaits a role in a future painting.

Part of **a poem I letterpressed** onto vintage graph paper.
Above are some of my little, imaginary fruit doodles.

A **simple, gold, foil doily** from a bakery. I like to use
this as a stencil for the background of paintings.

A **vintage pink shoe tag**, a bit of fun ephemera

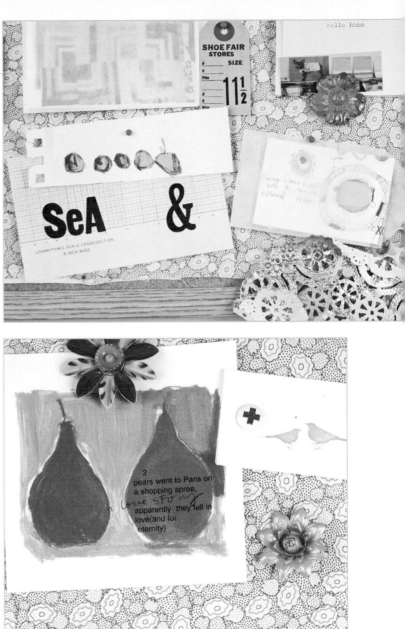

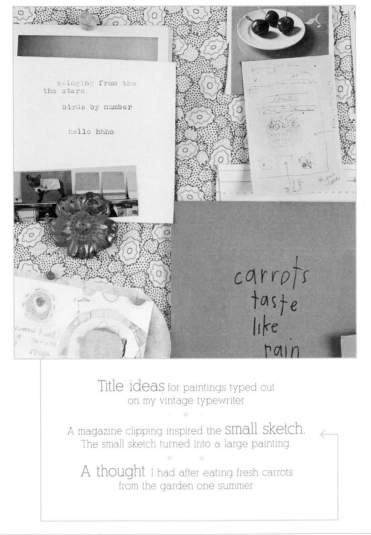

Title ideas for paintings typed out
on my vintage typewriter

A magazine clipping inspired the **small sketch**.
The small sketch turned into a large painting.

A thought I had after eating fresh carrots
from the garden one summer

One of **my favorite cards**--the bold colors make me happy.

Little, letterpressed birds tacked up with
a vintage **Red Cross button**

A bright **yellow ticket stub** reminds
me of a favorite outing with my husband.

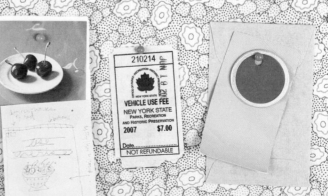

warm-up activity:
mini "scrap books"

Begin a new art-making session with a nice, clean workspace and clutter-free desktop. This is important because it's likely you'll make a giant mess when you're working, which, of course, is all part of the fun. For me, the prework, big studio cleanup has become part of my creative process; it's necessary to pick up the previous mess before I make a new one. The tidy space will help you focus and feel that you're making a fresh start.

When you are cleaning off your table, be sure to save all the little leftover clippings from your collage papers. Instead of just sweeping them into the recycling bin, save these little bits of paper in folders, tins, or boxes to use in future mixed-media paintings.

Often before I sweep my pile of scraps into the tins, I'll use them for a fun warm-up activity to get my creative juices flowing. I collage with the little bits of papers in my "odds-and-ends scrap books." I am constantly going back into these little books of mine to look at the compositions, colors, and ideas that emerge during these sessions. They become little reference books for future paintings.

Here's how the process works. Try it out for yourself!

try it out!

YOU'LL NEED

~ a 4" x 4" (10 x 10 cm) square sketchbook

~ small scraps and leftover paper bits

~ a small brush

~ gel medium

~ a few pencils or pens

THE RULES

• Don't think too much!

• Only use the pieces as you find them. (Notice that no scissors are listed above.)

• Think of this as a stream-of-consciousness activity; just play and enjoy the process!

• There is no right or wrong result.

• Arrange the scraps in your book in a combination you like. Apply the gel medium to glue them down. Use a pen or pencil to add notes or embellish as desired.

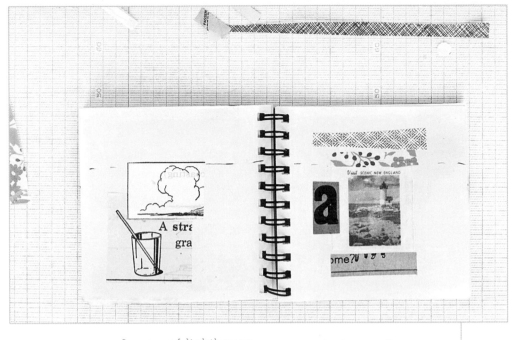

Image of lighthouse is a sugar packet from a café.

*

A piece of an envelope liner and tissue paper

*

The "a" is a letterpressed leftover from a poem I printed.

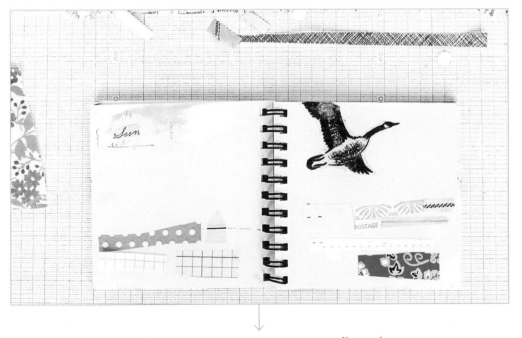

A goose flies over a patchwork "landscape" of collaged scraps.

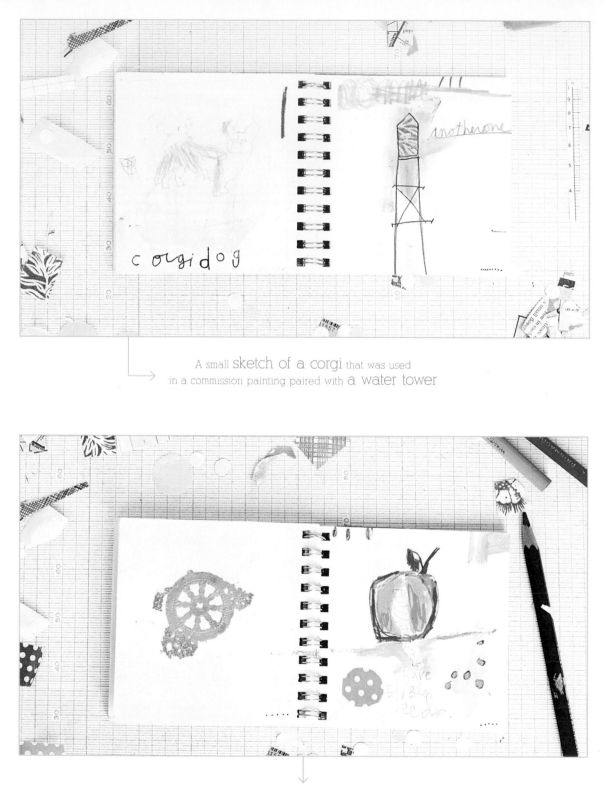

A small sketch of a corgi that was used
in a commission painting paired with a water tower

A piece of a gold doily and a small doodle of fruit

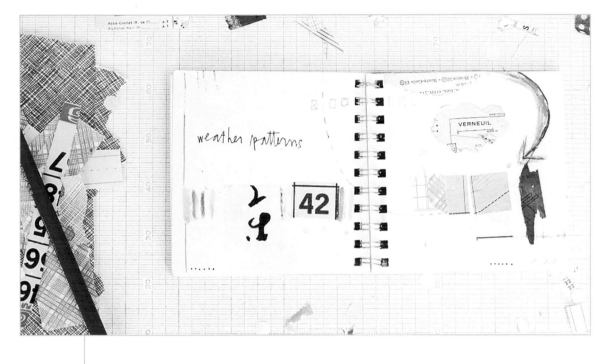

Blue security envelopes, bingo sheets, vintage maps, and chopstick wrapper scraps make up this "weather pattern" collage.

setups

Another way to work out ideas for paintings is by making setups with some of your favorite possessions from your home or studio. These setups can help you work out a framework or layout for a final painting. You can use physical objects such as books, magazine tear sheets, old postcards, doodles, vintage maps, and whimsical objects. The setups are not necessarily permanent; they can be easily changed around and re-worked. If you like what you've made, snap a photograph and add it to your sketchbook! These setups are a fun and easy way to inspire color compositions and spark ideas.

Sometimes I put collections of inspiring images up on my chalkboard to sit with for a while (opposite). I use the chalkboard much like an oversize sketchbook; I keep lots of notes and ideas written on it. When it's time for a change or it's getting crowded, I make sure to take a picture for my files. See how this collection of images informs the painting discussed in chapter five.

These objects, the photograph, and pieces of flowered paper (shown below) were what remained recently when I cleaned off my worktable. I piled everything together and then arranged it in a composition I liked. I just love the colors, feeling, and story that emerged. What a happy accident! See how this setup turns into a painting beginning on page 90; the completed painting appears on page 123.

Setup with books, bird, and block

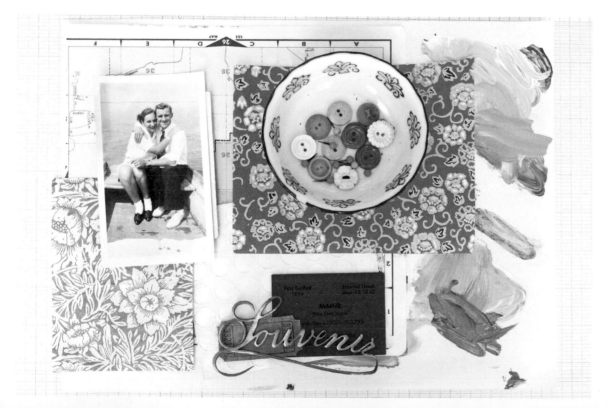

Setup with inspiring leftovers

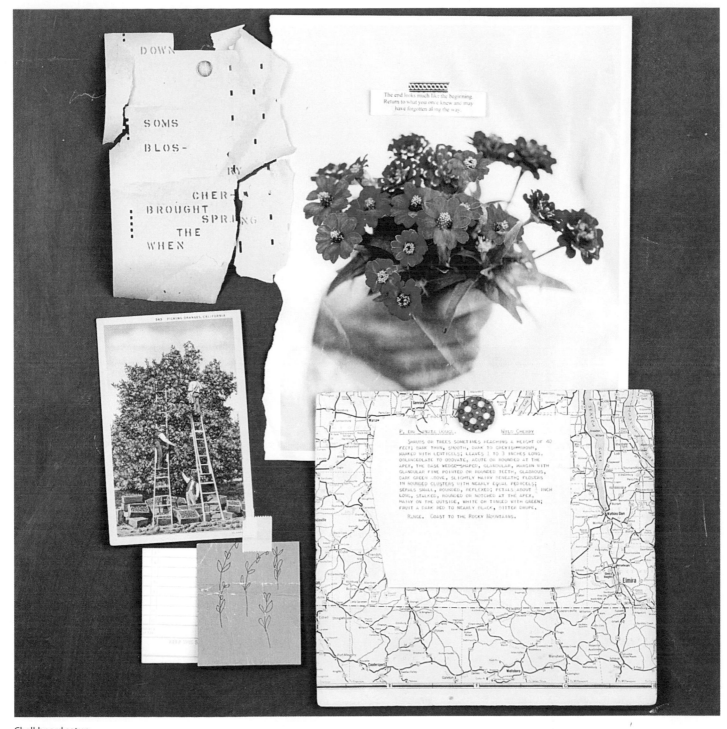

Chalkboard setup

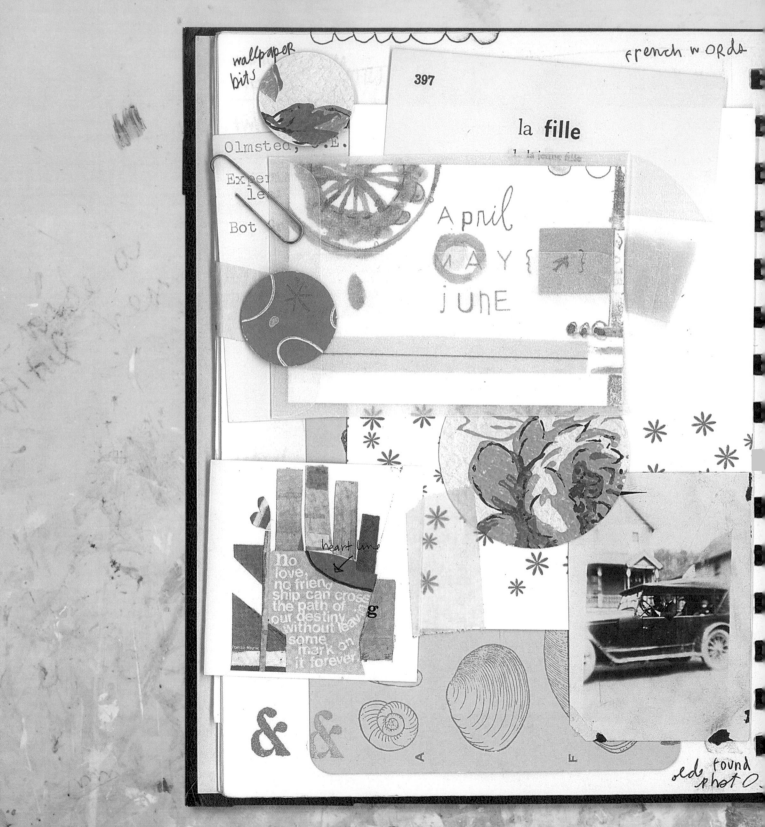

today i am inspired by it's april · 2009

1. BIRDS WITH maps FOR wings.
(so they know where they're going)

warm sun mixed
with cool spring
rain.

forsythia
② begins
to blossom

7. fresh eggs of many
colors from
the farm.

more+more
and ↓ more
{ + + + }

{ i need this }
yellow (B.)

3. A. B. c. d. e.

For whatever we lose (like a you or a me)
it's always ourselves we find in the sea.

6) poems by
e.cumming's

4. sprout.
seeds. begin to grow.

5. smooth round stones { as small as the world
and as large as a tone

This sketchbook
spread is called
{april inspirations.}

The collage is paired
with my drawing of
forsythia beginning
to bloom {love that bright
yellow!}, some
doodles and lists of
ideas for paintings. I've
also written out parts of
a poem and noted the
weather. All of these
recorded bits
were inspired by
the season.

from "scrap book" to sketchbook

Once you've warmed up in your mini scrap books and with setups, move into your sketchbook as the final preparation before you start a new painting. I think of my sketchbook as one of my most important art-making tools, and I take it with me everywhere. It's really like a portable little studio; just take your favorite pen or box of supplies along with you and you'll never miss out on the chance to record an important creative idea. Your sketchbook is the place to note fleeting thoughts, daydreams, lists of ideas, poems, an occasional to-do list, stories, and lots and lots of little doodles.

And yes, there are some actual sketches in my sketchbooks, but don't expect to see me quietly sketching still lives or portraits. The sketches I make are ideas or memories drawn out quickly, usually in black pen, as a way to remember the fleeting idea for a future painting.

I am constantly going back into past sketchbooks for reference, and you should too. Sometimes, when you are stuck on how to start a new piece, look back at past sketchbooks and you might find just the doodle or note that will give you the direction you need to jump-start the painting.

The image of my grandmother sitting on the beach, (below), became the focal point of the sketchbook collage on page 48. A colorful frame of flowered paper surrounds the image transfer of the black-and-white photograph. I imagine that her bathing suit might have been patterned in similar colors. I liked the "oceany" blues that began to appear as I added other collage bits such as the paint chip, the piece of the security envelope, and some other cut-up pieces of my own collages. My grandmother always signed her cards with Xs and Os, so the letters were added to remind me of her handwriting and that special gesture.

I paired the image with a poem by e.e. cummings on the right-hand side of the sketchbook (see page 49). The poem is about three little girls playing on the beach. My sister and I spent every summer with my grandmother, and we played on the very same beach where she sits in the photograph, so the poem seemed fitting to the story I was telling through this collage.

On page 44, I've collaged a few of my favorite things:

Vintage wallpaper bits

* * *

A found, old photograph

* * *

A glassine envelope holding
a tiny painting

* * *

My letterpressed scraps
of stars and seashells

* * *

A favorite quote on a
small note card

* * *

A French vocabulary
flashcard

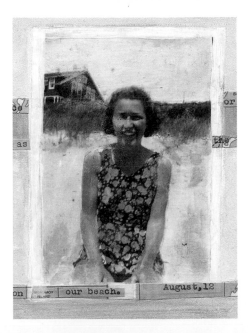

See how the sketchbook collage on page 48 inspired this painting found on page 73.

Opposite page: I keep all my sketchbooks nearby when I'm painting. They are my go-to reference for ideas and inspiration.

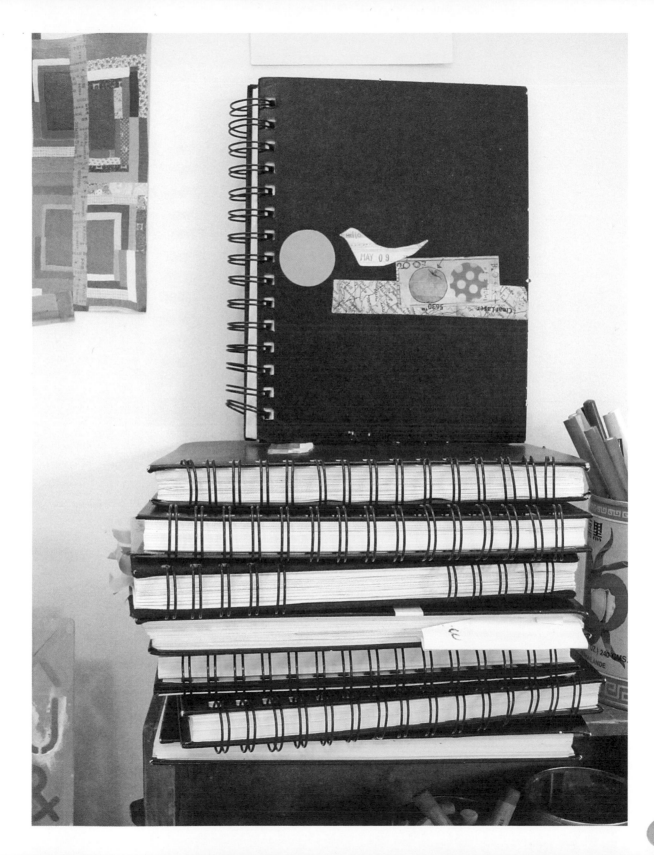

XO XO XO

S
T
U
V
W
XOXO
Y Z

{dove gray}

{1} 2. 3. 4. 5.

"vintagey" COLORS

LA1118 Vintage Blue

Lark

a poem by e e cummings

maggie + milly + molly + may
went down to the beach (to play one day)

and maggie discovered a shell that sang
so sweetly she couldn't remember her
troubles, and
millie befriended a stranded star
whos five rays languid fingers
were;
and molly was chased by a horrible
thing
which raced sideways while blowing
bubbles : and

may came home with a smooth
round stone
as small as the world and
as large as alone

for whatever we lose
(like a you or a me)
it's always ourselves we find
in the sea.

x o x o

read on 4.21.09

See how these pages
inspired the painting
on page 73.

getting out with your sketchbook

It's always important to keep the well full of inspiration. Sometimes a change of scenery is just what's needed to spark a new idea. If you are feeling stuck artistically, it is time to head outside or just take a break from the studio. Our creative energies tend to ebb and flow, and that's all part of the process.

Here are some of my favorite ways to get reinspired. Try them out for yourself!

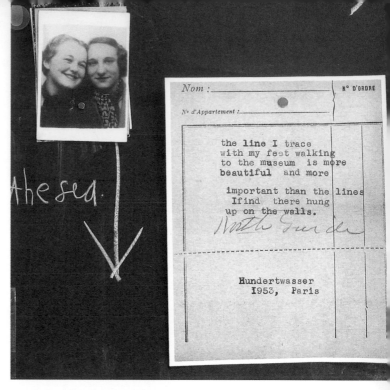

A quote from one of my favorite painters, Hundertwasser, typed out on a French receipt found in an old dictionary. These words permanently hang on the chalkboard in my studio because I just love the sentiment. It reminds me to get outside and explore.

~ Take a walk. Explore a new-to-you neighborhood or park. Sit on a bench with your sketchbook and see what emerges. Write down how you feel or what you see. Doodle. Pick up leaves or flowers along the walk to glue or tuck into envelopes in your sketchbook.

~ Head to a local gallery, shop, or bookstore. Window-shop and look for color combinations, styles, or designs that speak to you. Record these in your sketchbook. Look at books or magazines for inspiration and new ideas.

~ Go to a local museum for the day and take along your sketchbook. Really take the time to look at the artwork on the walls and in the galleries. You may be introduced to a new artist or style that will inspire your own work. Sit in front of a piece that speaks to you and just look at it for at least five minutes. Then, in your book, sketch or write out your thoughts about what you like about the piece. Perhaps it's the composition, the colors, the subject matter—whatever it might be, this is a great way to learn and soak up new ways of working. Be sure to pick up postcards from the museum shop or grab a free brochure to add into your sketchbook as a way to remember your visit and what you saw there.

~ Go to your favorite café or coffee shop and sit for an hour or so while working in your sketchbook. Being in a public place while you work is a good way to uncover new ideas and learn to let your guard down. Also, you never know who might want to strike up a conversation with you. Sitting in public with your sketchbook might feel daunting, but be sure to treat yourself! I always find that coffee and cupcakes can solve any problem.

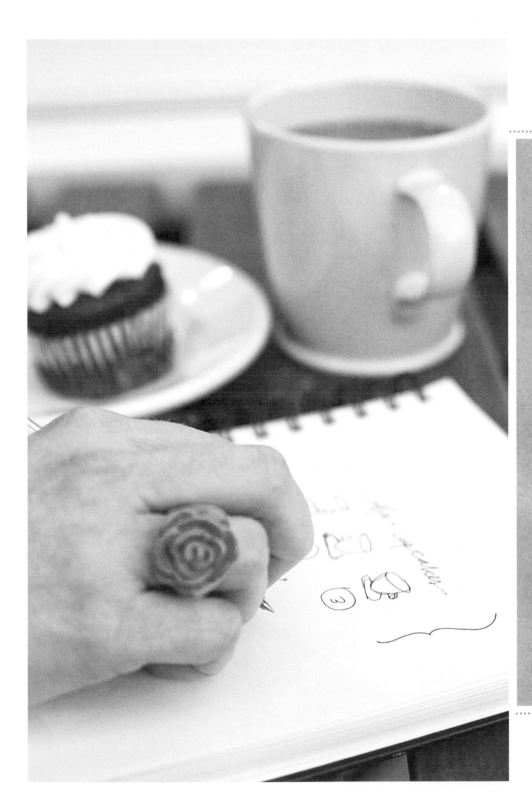

reach out!

Reach out to connect with other creative people in your community.

It's important to take a step away from the quiet of your studio once in a while. Getting together with another artist friend can spark new ideas and even rewarding collaborations.

Try setting a monthly coffee date with other like-minded friends at a local café or at each other's studios. Have everyone bring along current projects for feedback. Keep it a fun, supportive environment and encourage each other. Doing this once a month or so will keep you all inspired, focused, and on track with your work!

Escape your daily routine by attending an arts retreat where you'll be fully immersed in the artistic process. I've been lucky enough to teach at Squam Art Workshops in New Hampshire where I've seen firsthand how such a setting can have a magical effect on the participants.

{ A quiet, early spring evening outside, I found inspiration in the season's magnolia blossoms and the soft pinks of the seven o'clock sky, sketchbook in tow. }

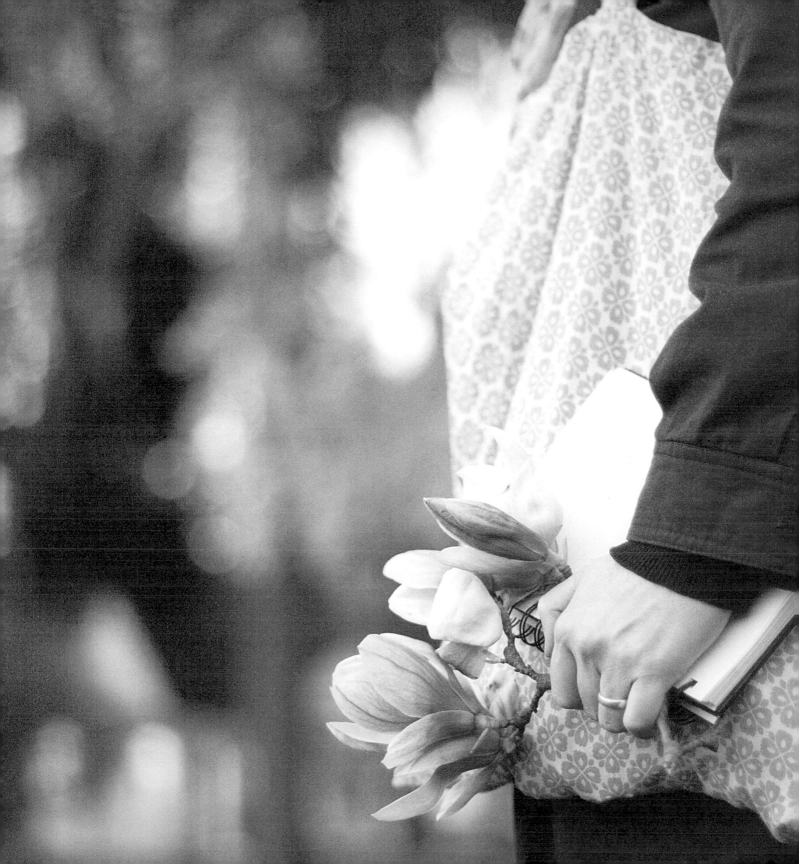

Shanna Murray
> *inspiration*

SHANNA MURRAY is a multitalented artist living and working in upstate New York. I am always drawn to her beautiful displays of inspiration in her studio, so I asked Shanna if she would share a bit about this process and how it informs her artwork. Shanna says that instead of keeping her ideas in a small sketchbook, she prefers a really big canvas for spreading out inspiration—preferably an entire wall! She loves that when she needs a jolt of beauty, or a reminder of her direction for a current project, all she has to do is look up. Living and working among torn magazine pages, lengths of ribbon, bits of nature, photographs, swatches of color, and pieces of tape makes her happy. When she comes across something that strikes

a chord in her, she stashes it away in a little wire basket on her desk. Each time she begins a new project, she sifts through the basket looking for bits that really speak to the direction she's leaning in. And then she just begins taping and pinning bits up in a manner that's pleasing to her. Once in a while she will swoon enough over something, it has to go up on the wall right away. When that happens, it's usually something that will stay on the wall long after other bits have come down and been replaced. Something that inspires for more than a project or season is rare, but when it comes along, she says it feels like magic!

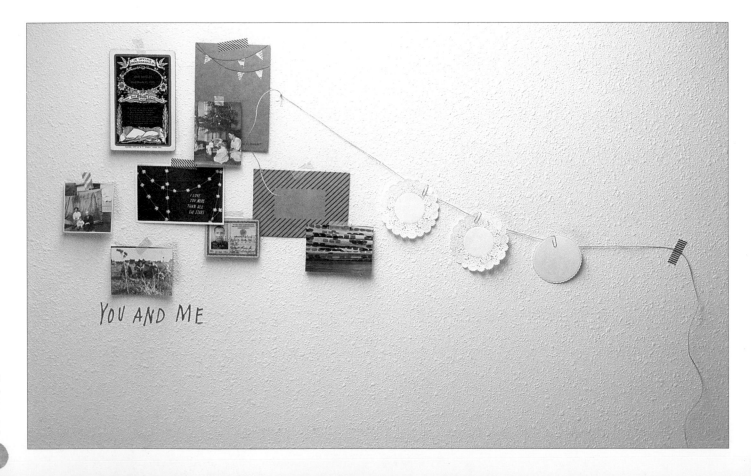

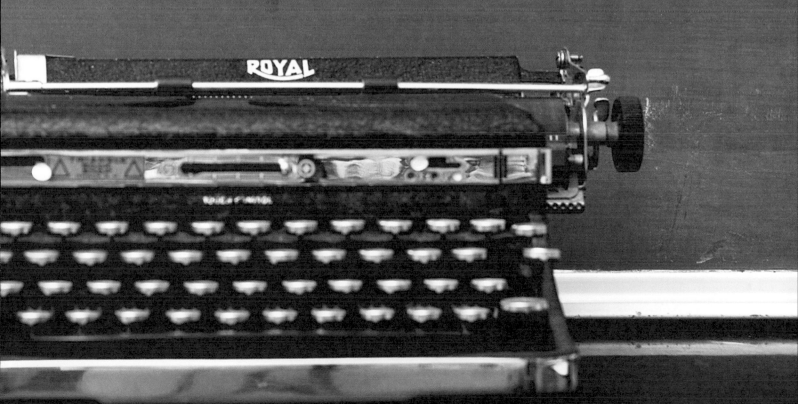

chapter three:
write it out

poems and paint ›

I originally began painting as a way to illustrate poems. At first, the poems were my own, but when I began reading the works of Walt Whitman, e.e. cummings, and Pablo Neruda, I became inspired to use some of their writings in my paintings as well. So from the start, text and image have always been intertwined within my work, and experimenting with combinations of the two has become an integral part of my creative process. For me, the words often come first and spark associations and images that I will record in my sketchbook. Later, I'll expand on these fragments and incorporate the ideas into a new mixed-media painting.

Sometimes, I will handwrite a full line of poetry directly into a piece, but often the text emerges from the collage materials themselves. My favorite source for found, printed text is my collection of old books. Vintage dictionaries, old schoolbooks, and outdated travel guides supply me with a never-ending stream of inspiration and collage possibilities. In addition to book pages, ephemera such as old science diagrams, maps, and dress patterns have numbers, letters, and words that take on new meaning when combined with paint and color in a fresh context. On the following pages, I'll show you how to use text and image in a variety of fun and unique ways.

My painting, *Parts of a Typical Bird*, was originally inspired by an excerpt I found in an early-twentieth-century bird-watching book.

* * *

I transcribed the introduction to the book onto the background of the painting in an informal, handwritten pencil script.

* * *

The parts of the bird are then individually labeled with small rub-on letters.

* * *

The edges of the painting are finished with pieces of an old children's dictionary, a found receipt, and bits of scientific papers; these collage elements serve as a frame for my bird portrait.

PARTS of A TYPICAL BIRD

Eye ring
Crown
Forehead
Lores
Ear patch
Nape
Upper Mandibles & Lower
Back
Scapulars
Throat
Rump
Breast
Upper Tail-coverts
Tail
Wing bar
Under Tail-coverts
Belly
Primaries
Side
Tarsus
Secondaries

paintings from poems: neruda's words inspire

I turned to the work of Pablo Neruda and his *Odes to Common Things* to spark ideas for my paintings. Like many artists, the Chilean poet found beauty in simple, everyday objects and activities. One of my favorites of his odes is that to a fallen chestnut. Here you can see my response to his words in my sketchbook and finally in a small mixed-media painting.

After reading the poem, I begin by gathering the bits and pieces of my ideas and recording them in my sketchbook. I then warm up by trying out colors and shapes to be used in the final painting.

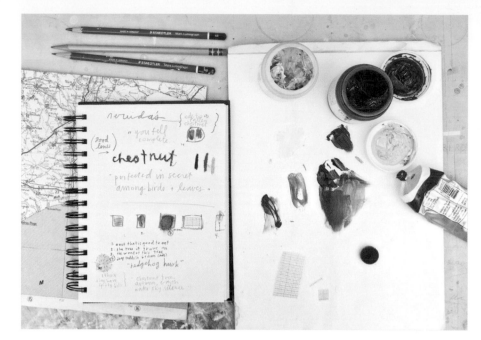

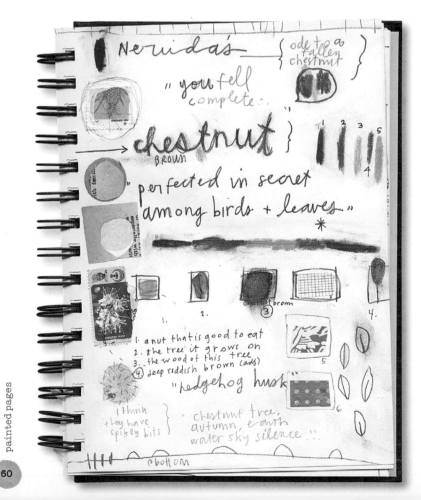

I read the poem a few times and jot down the lines that really inspire me, such as "perfected in secret among birds and leaves." These notes lead me to my canvas, and I begin to work. First I collage the definition of the word *chestnut* from an old dictionary onto the board. I then add an image of a robin in its nest on top of the words. As I work, I worry that the bird image is covering too much of the definition and wonder if I should rework what I have started. I decide to ignore that section for now and move on to the rest of the piece by adding color with paint, collaged papers, and colored pencils. When I reread my favorite line from the poem, "perfected in secret among birds and leaves," I realize that those words must have been in my mind inspiring my process all along! I've covered a bit of the word *chestnut* with an image of birds and leaves, and I decide to leave the composition just as it is: a surprise connection between poem and paint.

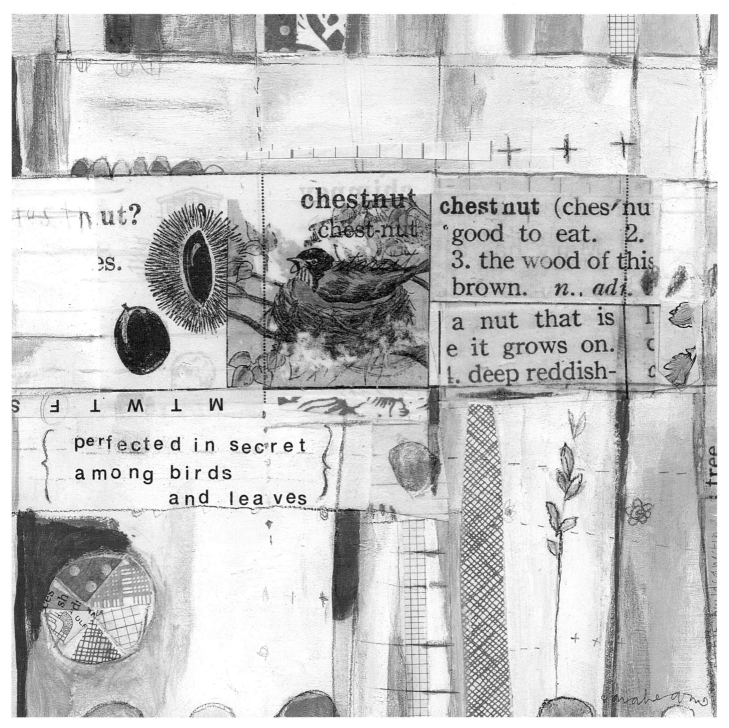

chestnut? es.

chestnut
chest-nut

chestnut (ches´nu
good to eat. 2.
3. the wood of this
brown. *n.. adi*

a nut that is
e it grows on.
deep reddish-

M T W T F S

{ perfected in secret
among birds
and leaves }

tree

Here you see my completed painting based on the poem, "Ode to a Fallen Chestnut," by Pablo Neruda.

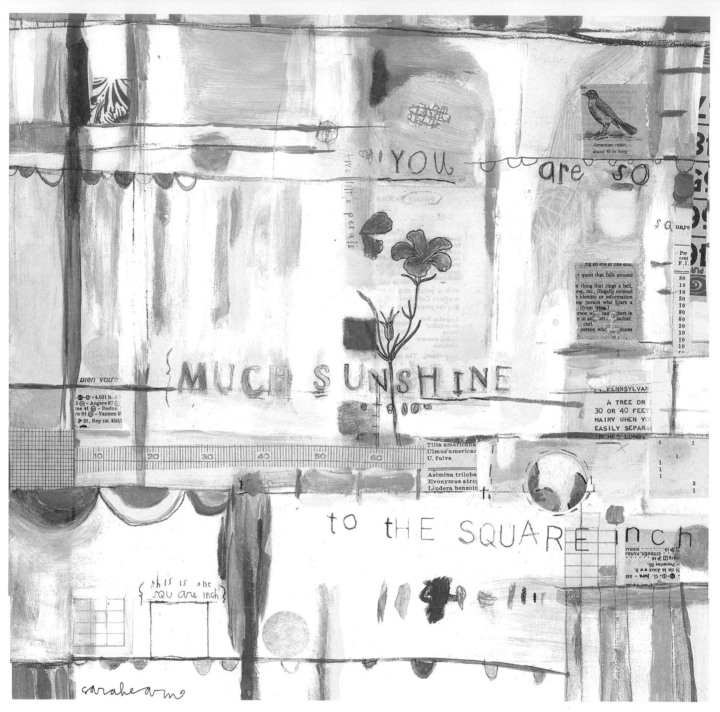

Walt Whitman once said, "You are so much sunshine to the square inch." When a friend sent me a card with that quote on it, I knew I had to use the quote in a painting, as it really resonated with me. Here, I have taken those words and built a painting directly inspired by them. The larger text in this piece is handwritten in pencil over some rubber-stamped letters; the smaller text is made up of hand-applied vintage scratch letters. Building from this quote, I've layered bits of collage relating to the theme of measurement, as I've titled the piece *Measured in Sunshine*. Strips of old ledger paper, numbered charts, and graphs add to the overall composition and help to tell a story.

In some of my paintings, the text is much more subtle. Such is the case in this piece, entitled *More than One*. The painting is inspired by a favorite e.e. cummings poem about flowers growing in the spring. I've handwritten that line from his poem across the piece below.

I have based the painting on these lines from the end of the poem (in box, at left). The text is less obvious as compared to the painting on the opposite page, but the words are just as important. Alongside the handwritten poem, I've included "found" text from chopstick wrappers, old postage stamps, and a fortune from a fortune cookie. The words and numbers found on the bits of collage, combined with the painted image of flowers, work together to tell the story of growth in spring.

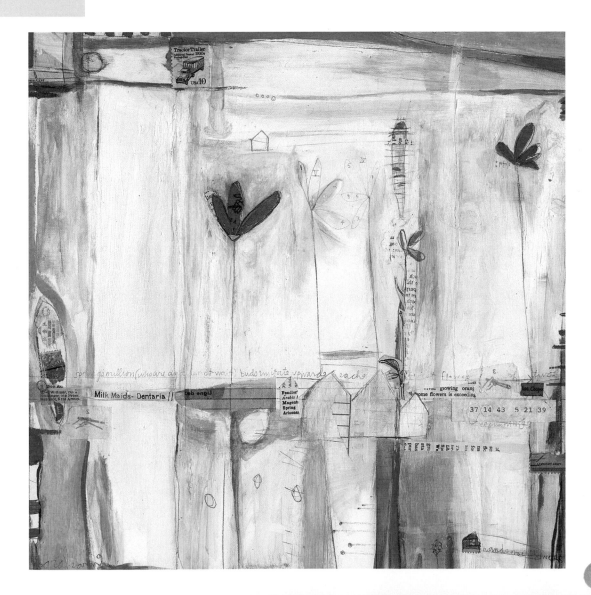

{ i'd like to be here }

{ a list for summer }
(things to remember)

1. soft (+ pinky) evening light
2. july sky : bright blue with just
 a few clouds

3. beach side roses (wild + bright) □

4. long patches of sand at low tide

5. clam shacks + boardwalks
6. green green grass with barefeet
7. salty air + sunshine

8. impromptu picnics :

where: on a grassy hillside in the shade

to eat: radishes
fresh from the farmers' market. pinky purple slices dipped in sea salt.
grilled corn on the cob, peaches, basil + tomatoes
to drink: minty iced tea (served in a tall
pink lemonade + vino verde glass, extra ice + mint leaves)

My many sketchbooks
are filled with lots
of handwriting
alongside drawings
and doodles.

* * *

I most often use the
pages to
record ideas
for my work.

* * *

Other times, I'll use
my sketchbook to
take notes when
I go to artists' talks at
museums or galleries.

* * *

I also use my books to
list my ongoing ideas,
daydreams, and
creative goals:
usually these thoughts
end up in a loose list that
looks something like this.

write it out

5 things about
{ summer }

1. swimming in the sea
2. ice cream cones
3. farmers markets
4. picking raspberries
5. salt air in the evenings

sarahearn

The sketchbook lists often turn into paintings, and the lists can often help to spark or clarify creative ideas. It's also said that if you write it down, you'll follow through and make it happen. Here are few ideas for your own sketchbook lists:

* lists of your current goals
* a wish list
* lists of current inspirations
* lists of favorite places
* your art to-do list
* lists of favorite childhood memories
* lists of seasonal observations
* lists of special things you notice in your day-to-day life

reach out!
[collaborate with a creative friend]

Recently, I collaborated with a friend of mine who is a poet. In our yearlong project called *Two Days in July*, she sent me a new poem each month that I would illustrate through mixed media. We began posting the poems and paintings paired together on a blog. Through this process, we both stretched our imaginations and got out of our respective creative ruts. Painting from her writing was sometimes challenging, but mostly it was freeing and a fresh new way of working for me. During this process we both realized we had developed a new habit; through our art, we were connecting and communicating with each other at least once a month, in turn rekindling a special longtime friendship. Long before our blog, Kate and I had a journal we would share and pass back and forth. She would write poems in the book and use it as a journal, and I would draw or paint in it and use it more like a sketchbook. The book, of course, was a more tangible way to work together, but the blog was a natural, more modern extension of our process. It also allows us to communicate with an audience and work together even though we live far apart.

Seek out a creative friend and come up with a similar project you could do together.

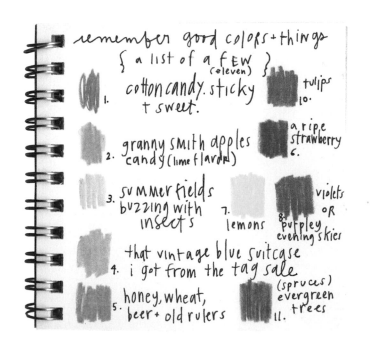

remember good colors + things
{ a list of a FEW }
(eleven)
1. cotton candy, sticky + sweet.
10. tulips
2. granny smith apples candy (lime flavor)
6. a ripe strawberry
3. summer fields buzzing with insects
7. lemons
8. violets or purpley evening skies
4. that vintage blue suitcase i got from the tag sale
5. honey, wheat, beer + old rulers
11. (spruces) evergreen trees

text and image combinations

You can have a lot of fun experimenting with text and image combinations. In addition to your own handwriting and found text from books, you might try using tools such as a vintage typewriter, rubber stamps, scratch letters, stickers, or stencils to add layers of words to mixed-media pieces.

Often a line or word in an old book will spark an idea for a painting. In this case, I was looking up phases of the moon in one of my old science textbooks. Here are two pieces from my ongoing "moon series;" the text in both springs from snippets I read about moon phases.

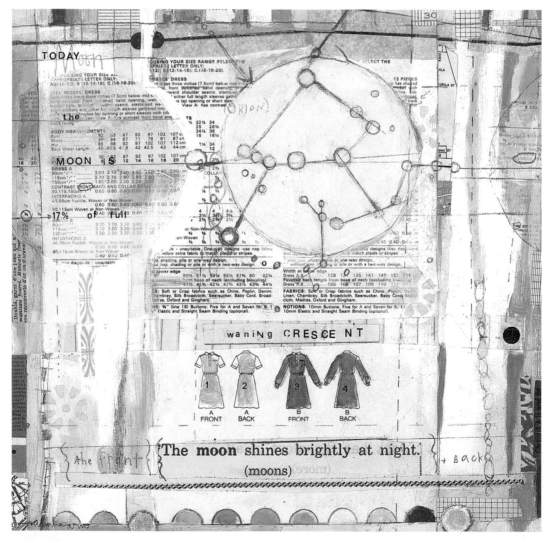

Front and Back of the Moon

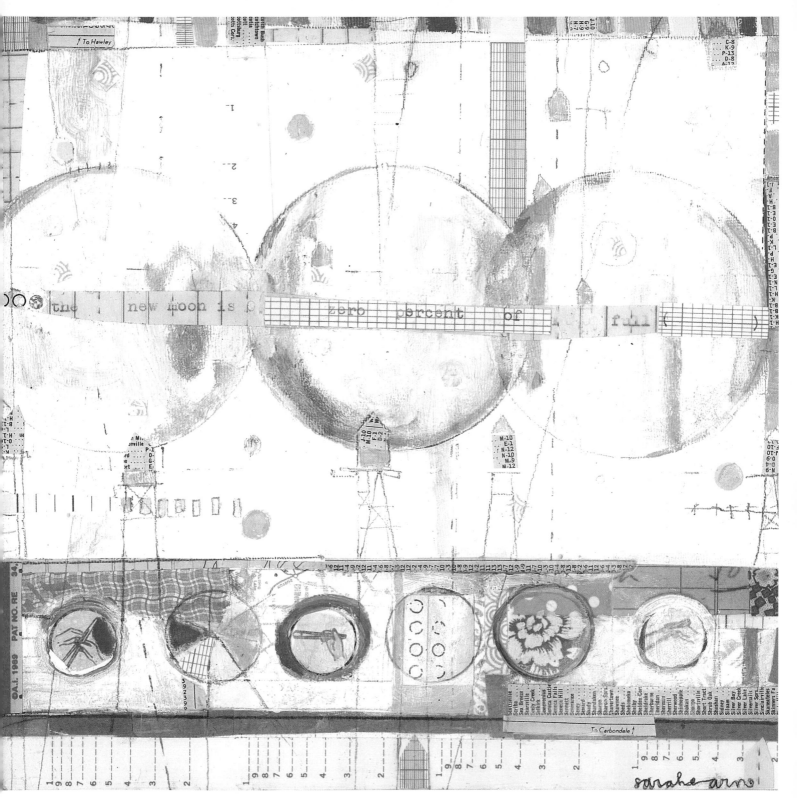

The New Moon is Zero Percent of Full

dictionaries

I've always loved looking through old dictionaries, and I have an interesting collection of different kinds: vintage children's dictionaries, unusual foreign-language dictionaries, beautifully illustrated picture dictionaries, as well as a wide variety of the classic Webster's dictionaries from years past. Sometimes by just flipping through them and reading various definitions, I get ideas for paintings. You can often find these treasure troves of inspiration in used-book stores and at library book sales.

check it out

These are some of my favorite well-known contemporary artists who use text and image in their work. Look them up and see what you think. Maybe they will inspire you as much as they inspire me.

- Robert Rauschenberg
- Jane Hammond
- Cy Twombly
- Jaune Quick-to-See Smith
- Jean-Michel Basquiat
- Squeak Carnwath
- Lesley Dill

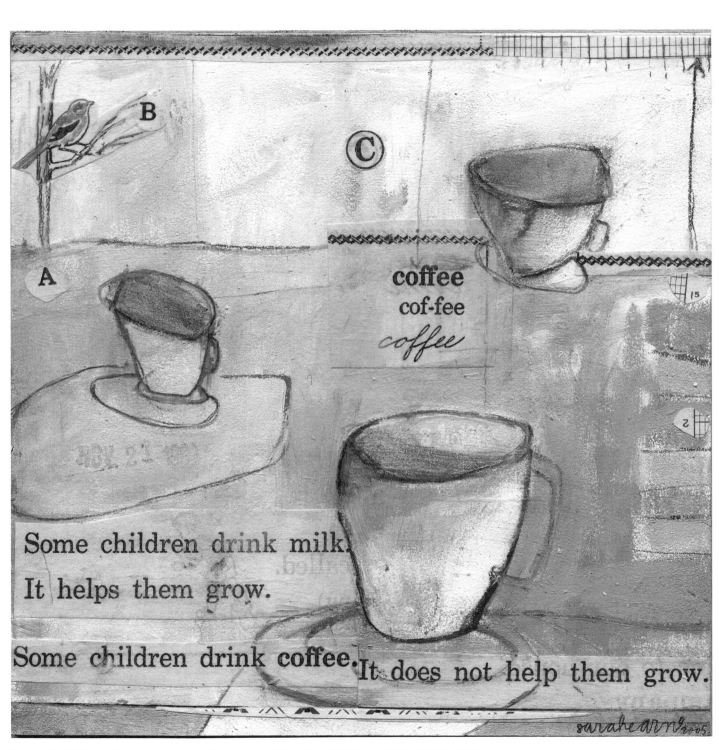

Some children drink milk.
It helps them grow.

Some children drink coffee. It does not help them grow.

coffee
cof-fee
coffee

This was the "definition" for *coffee* in a picture dictionary for children from 1939. The wording is so quirky, and it made me laugh when I read it. It's one of my favorite combinations of word and image. I rarely keep any of my paintings, but this original hangs in my kitchen, and it really seems to strike a chord with coffee lovers.

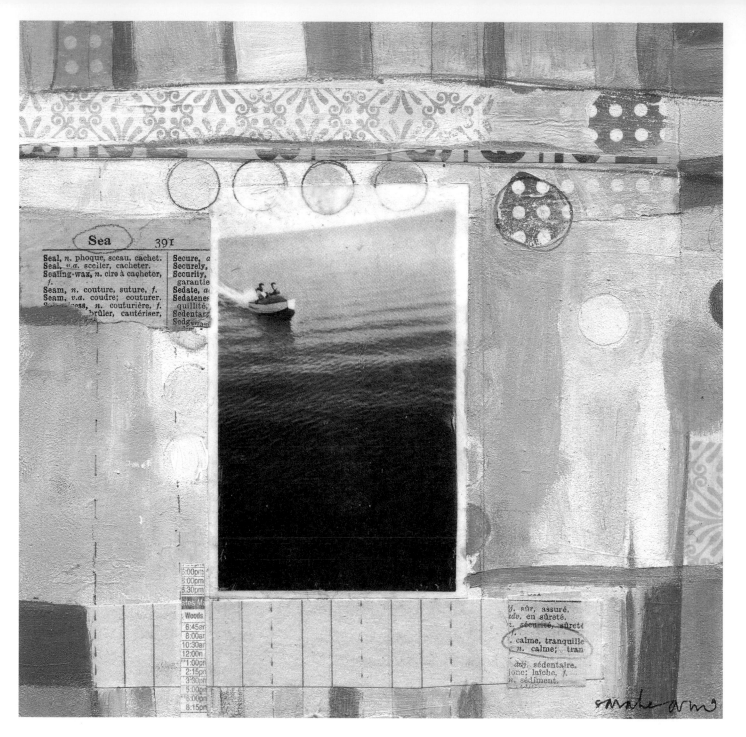

Titled *Calm Sea*, this painting features a favorite old black-and-white snapshot taken by my grandfather in 1938. He was riding on a ferryboat when he captured this image of a couple in a small boat smoothly sailing by. I decided to use this striking image as the centerpiece for one of the first paintings I made using

family photographs. As I looked at this snapshot, the words *calm sea* popped into my head; those words led me to the title as well as the soft, subdued color palette. The simple collage element was from a small French dictionary. The definition was just right to complete the story.

Personal family photographs have become the inspiration and focus for much of my artwork. To use your photographs in paintings, make contact-paper transfers of the images. The transfer process allows you to save the original photograph while transforming it into a unique, translucent collage element. You'll learn in the next chapter how to make image transfers like the one you see here.

The painting below is based on the original sketchbook study shown on page 48. My "notes" from that sketchbook spread informed the color palette and led to the vintage feel behind this finished piece.

The small text throughout the painting is the Webster's definition of *beauty* on a faded Cape Cod map typed with a vintage typewriter. The painting, titled *A Particular Grace*, marries the words with a lovely picture of my grandmother on the beach from 1937. In this photograph, she is the ideal described by the definition. In my own mind and heart, my most treasured memories of childhood were spent with her on that very same beach on Cape Cod where she sits in the photo. Those memories flow constantly as I paint and continue to inspire most of my work today.

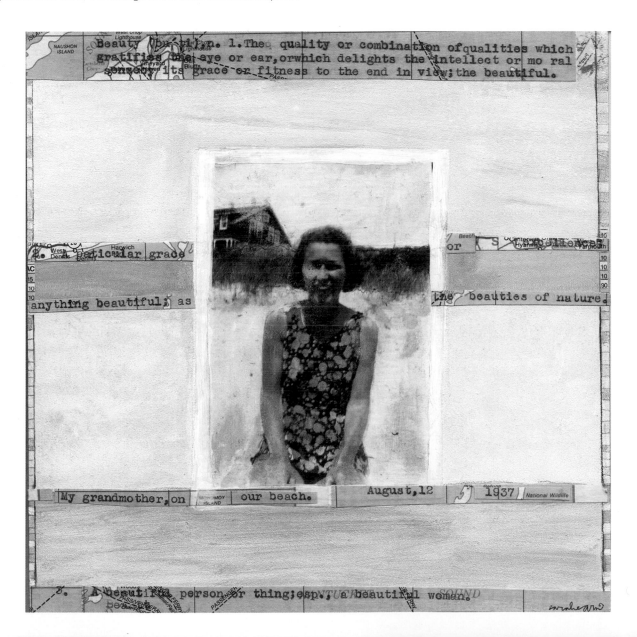

KARI AND CHRISTINE are both writers and all-around crafty gals living in New England. I've asked them to share a bit about their writing and visual arts processes. I was curious about how those two practices might reinforce and inspire one another.

KARI CHAPIN NIXON confesses that she doesn't feel she draws very well, but when she described her intriguing sketchbook process, I was thrilled when she agreed to give us a peek inside. Whenever she is preparing for a trip, she draws out her packing list in her sketchbook, right down to the small details such as accessories and the number of socks to bring. Even though she's a writer and keeps regular written lists, drawing out her packing list helps her visualize just what she needs for a trip and helps her feel more organized and ready to go. This is a fun yet nontraditional way to incorporate working in your sketchbook into your everyday life. Next time you head out on a trip, try it! More important, add that sketchbook and some colored pencils to your drawn-out list and toss them into your suitcase as well. A vacation is the perfect time to relax with your sketchbook, to write down memories of your trip. When you get home you could add items such as ticket stubs and photos to remember your time away.

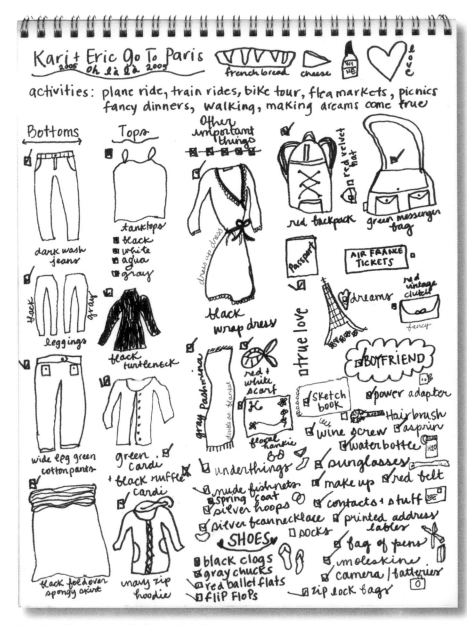

Kari's sketchbook packing list for her trip to Paris

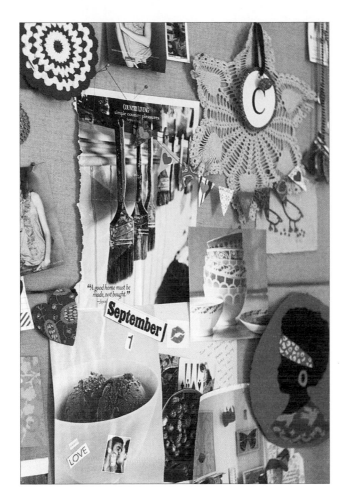

It was very difficult in the beginning as she tried to write about subjects she thought would be trendy and popular but were not what she was truly passionate about. Her epiphany came when she opened her eyes to what was all around her: her studio, where she sews, knits, crochets, and creates, is filled with inspiration boards. The images on those boards all depict art, artists, and small businesses she admires. She has clippings of artist studios as featured in magazines; creative indie business cards; scraps of beautiful, handmade paper; and even small art prints.

Christine soon began to understand that writing about artisans, small businesses, and creative entrepreneurs was her true passion, and with that discovery, her career finally took off and she began publishing in magazines she had once only dreamed of contributing to.

Christine says that when she is writing, whether working on an assignment or journaling, she surrounds herself with images she finds inspiring. This helps keep her mind focused on the task at hand, and often the images evoke certain emotions and words she can then use to make her writing richer.

CHRISTINE CHITNIS says she writes both as a way to understand the world and to make a living. She discovered her passion and talent for writing when she worked in the nonprofit sector, where she wrote grants and promotional materials for a cause she cared deeply about. When she moved to a new city and left that job behind, she decided it was time to strike out on her own as a freelance writer.

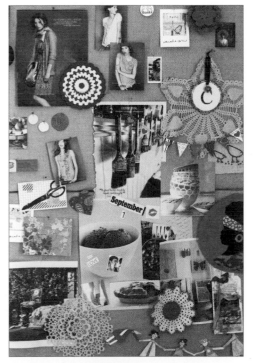

Christine's inspiration boards

chapter four:
pick it out

pick
sick
click
like
lick

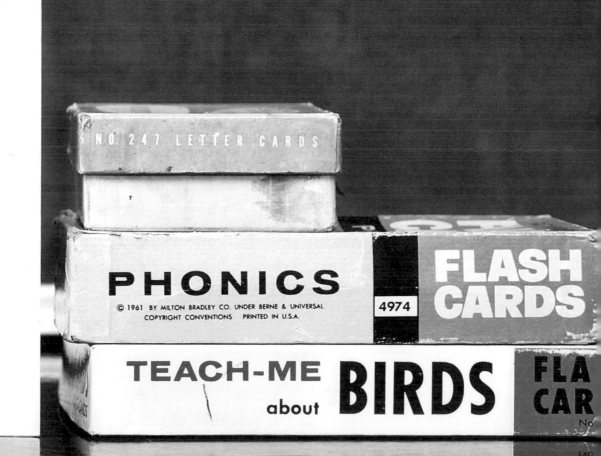

NO. 247 LETTER CARDS

PHONICS

© 1961 BY MILTON BRADLEY CO. UNDER BERNE & UNIVERSAL
COPYRIGHT CONVENTIONS PRINTED IN U.S.A.

4974

FLASH
CARDS

TEACH-ME BIRDS
about

FLA
CAR

incorporating collections ›

Just as I began painting as a way to illustrate my poems, I started using collage
to make use of my many collections. I had always thought of painting and collage
as two separate ways of making art until I discovered the "right" kind of collage
materials to work with.

One day my husband brought me a pile of old pamphlets that had been discarded
from the science library near his office. The pamphlets were made of papers so thin
and delicate that when I turned the pages, they often tore. I carefully studied these
old, forgotten pages, each filled with beautiful botanical illustrations. I was drawn to
the captivating interplay of text and image printed within each figure. Many of the
publications were written in French, which made them even more appealing to me—
an unabashed Francophile. Because the pages were so thin and translucent, they
could be subtly layered into my paintings, giving me a whole new way of working.
I soon began to search out other types of books with thin pages and discovered
just what I was looking for in antique stores, junk shops, flea markets, and at library
book sales.

It's a lot of fun to search through a collection of old books to find the perfect bit of
collage material to use in a piece. In fact, it's become a central part of my creative
process. I'm sure I have enough books to last a lifetime, but they continue to offer
endless inspiration for my paintings.

In addition to books, my collage source materials have grown to include outdated
maps, old dress patterns on tissue paper, vintage bird ephemera, and small black-
and-white photographs from the early twentieth century. In this chapter, I'll show
some examples and techniques for incorporating collections into mixed-media paint-
ings. I hope these will inspire you to start collecting ephemera and other collage
materials to use in your own work. I'll share some ideas to get you started, as well
as provide a more detailed and in-depth how-to technique for you to explore.

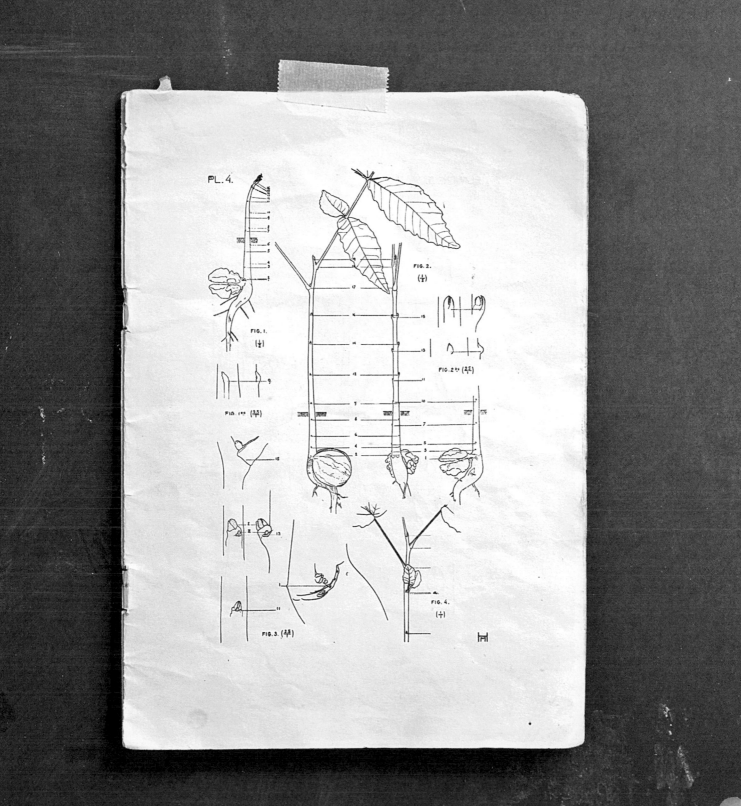

PL. 4.

start your own collections

Visit your local antiques or junk shops on a regular basis; you never know what might turn up.

Scour flea markets and yard sales for ephemera such as photographs, ticket stubs, postcards, and trinkets to use in your work or for pure inspiration.

Used-book stores and library book sales are great sources of not only books but also things such as maps, games, old pamphlets, and flash cards.

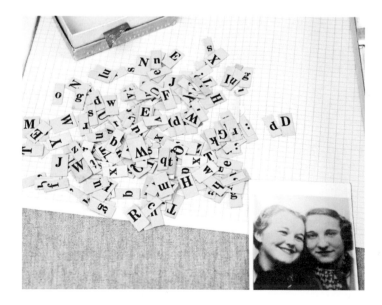

using your collections in your work

Fill your sketchbook pages with glassine envelopes to hold ticket stubs and old photographs.

• Rip out a page of an old book and use it for collage.

• Use an old sewing pattern as the background for a painting. The tissue has a nice translucent quality when glued down on your board with gel medium.

• Spread out an old map on the floor and use it as your canvas. Draw directly on it, connecting the lines and filling in the spaces with paint and color.

• Pick up an old dictionary; close your eyes and flip though the pages. Stop, open your eyes, and illustrate whichever definition your eyes land on first.

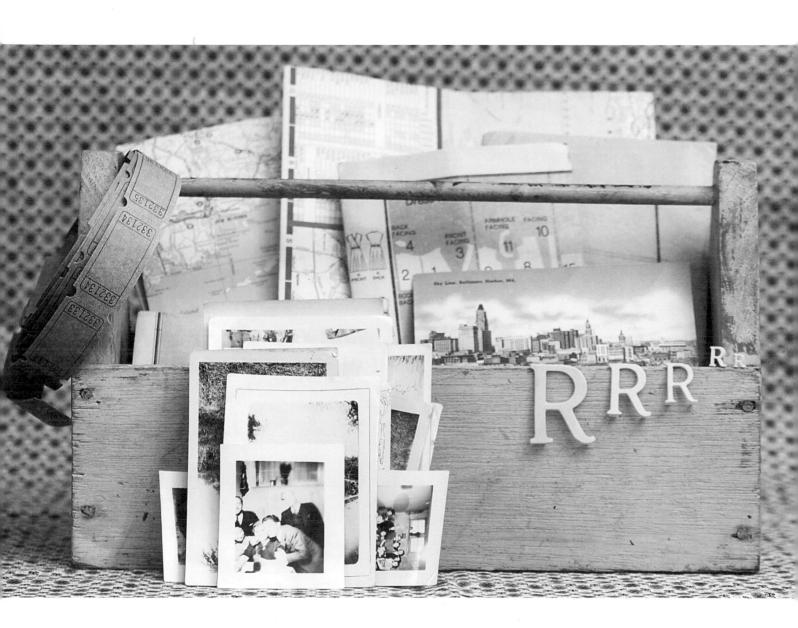

I became interested in birdwatching a few years back and decided to start collecting antique or vintage bird imagery. One day, while browsing a favorite local antique shop, I came across a set of what looked to me like little flash cards. Each card had a unique bird printed on it, and I was immediately drawn to the lovely illustrations, soft colors, and tiny size. Upon closer inspection, I was surprised to see that the cards are actually ads for Arm & Hammer baking soda from the 1920s. On the back of each card there is a bit of information about the bird, along with a slogan that reads "For the good of all, do not destroy the birds." Since then, I've continued to add to my collection of quirky bird memorabilia and always find it a good place to start when looking for an idea for a new painting. My ongoing series of little bird paintings features these collected cards, as they offer endless inspiration.

Collected bird ephemera hangs on the chalkboard in my studio for inspiration.

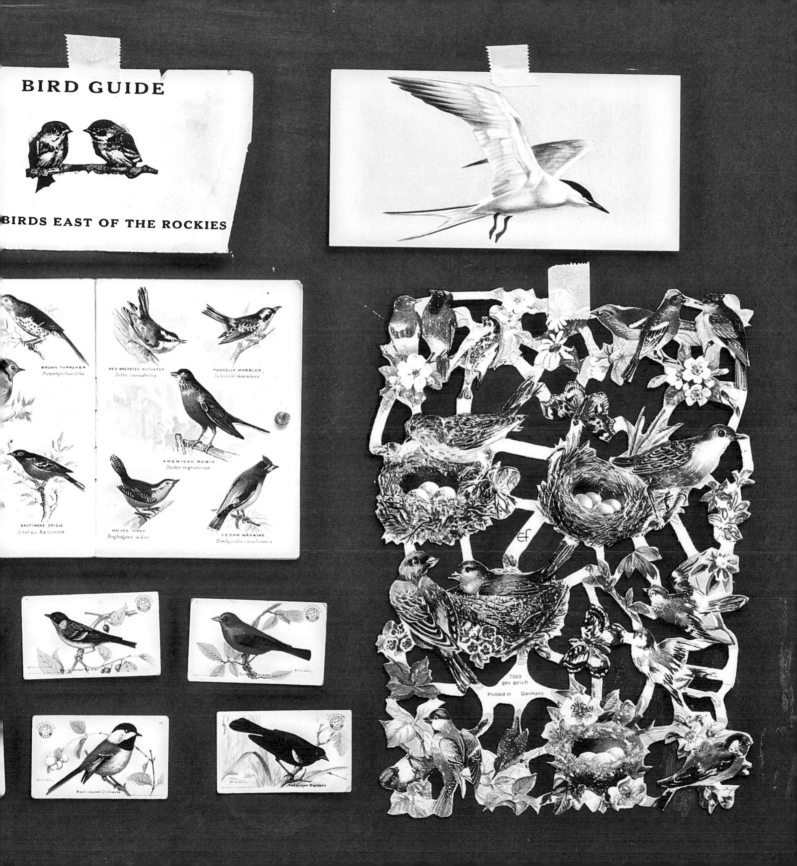

pigeon and dove family. (columbidae)

Pigeon-like birds. Birds with small heads, short

necks, wings painted or fan

either long and

shaped. Plumage

browns and soft and fair bre

soft tones. GRAYS in

gentle and Notes are

section V. cooing.

pg. 310

SECTION IV

Pigeon-like Birds

pigeon-like birds

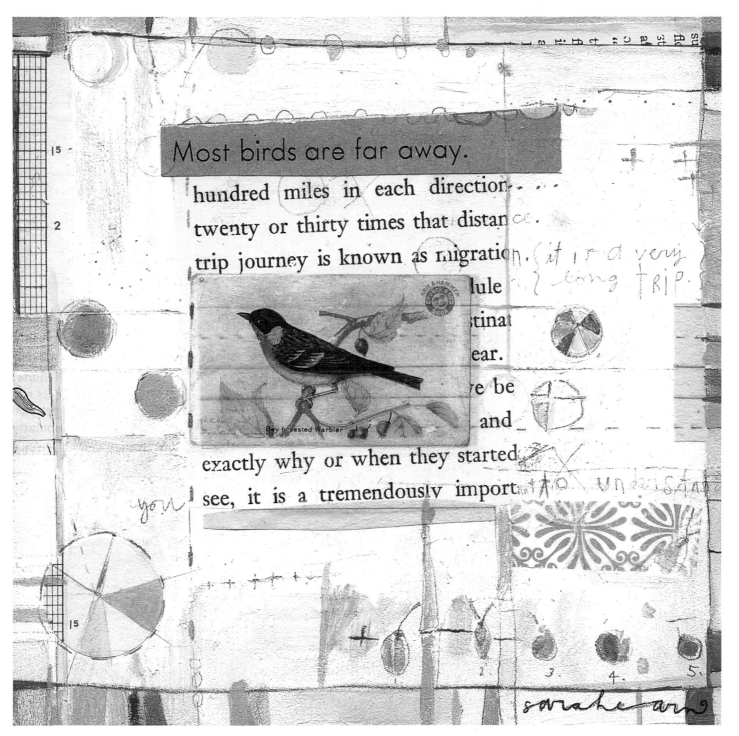

Most birds are far away.

hundred miles in each direction

twenty or thirty times that distance.

trip journey is known as migration. {it is a very {long TRIP.

lule

stinat

ear.

e be

and

exactly why or when they started

see, it is a tremendously import to understa

you

sarahe arn

most birds

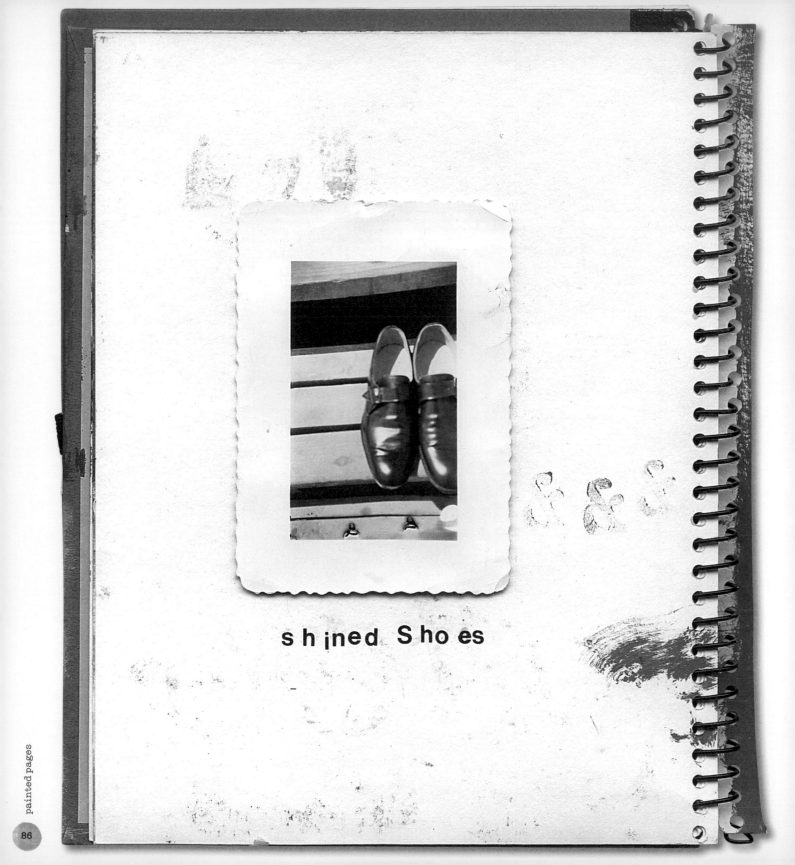

shined Shoes

every picture tells a story

It all started when my grandfather showed me a small black-and-white snapshot he had taken as a young man. It was a simple composition showing only a pair of his newly polished shoes, yet it struck me as one of the most beautiful images I had ever seen. Those shiny shoes gave me a glimpse into an era that came before me, a time when my grandfather was a young man with a passion for photography, capturing everyday moments with his new camera. What followed were many more photographs—in fact, a whole shoebox full of them, alongside wonderful stories about the many people and scenes captured in them. At the time, my grandfather was entering the early stages of dementia, and talking about the past was much easier than talking about the present. Together we sat in his office, slowly sifting through this shoebox of memories. I asked questions about each picture as he pulled them from the box, which allowed him to happily sit and chat with me, sharing his stories, confident in his thoughts and answers. This was not at all the case when talking about the present, as his mind had grown foggy and he had become increasingly frustrated and quiet. But to sit with that special box of photos in his lap and talk about the past with me really made his face light up with joy. After we had gone through the whole box, each picture one by one, he gave it to me "for safekeeping," and it was then that I decided I would figure out a way to keep all those special stories alive. I learned a lot about our family and its history during our time together and feel so lucky to have had that special, happy time with my grandfather before he passed away.

Thus began my extensive collection of small black-and-white photographs. It's one I certainly treasure.

In addition to my own family photos, I began adopting discarded family pictures and snapshots I came across in antique stores and at flea markets. To think that someone's family photo album would be sold off at an estate sale or auction just broke my heart. By using these found photographs of forgotten families in my work, I am, in a way, attempting to learn their stories and bring those stories back to life through paint and collage.

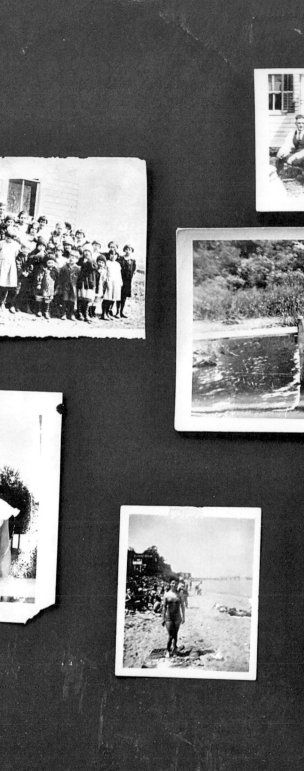

A few of my "Adopted" family photos hang on my chalkboard.

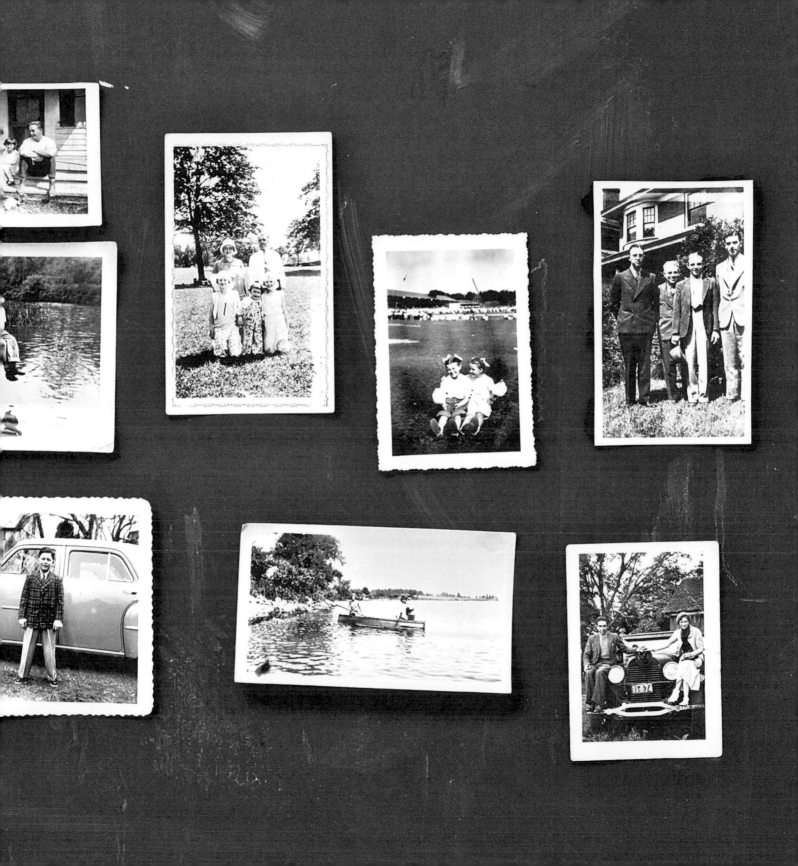

technique idea: image transfers

This simple image-transfer technique uses only photocopies of your images so that you'll be able to protect the original photographs and use them again and again. There are many different ways to do an image transfer—some use gel medium, tape, caulk, or essential oils—but I've found that using simple clear contact paper (shelf liner paper) is the easiest and cheapest, and it always delivers the best end result! Here I'll show you my own method for an image transfer using clear contact paper with step-by-step instructions. Try it out for yourself and see what you think!

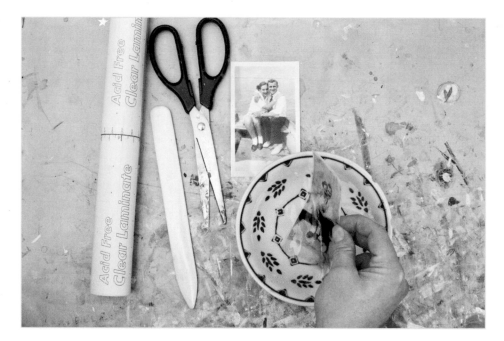

To get started, you'll need to gather some of your favorite photos and make copies of them on a laser color copier. Keep in mind that even if you choose to work with a black-and-white photograph, you will want to be sure your copies are made on a color copier because it will capture the sepia tones and aged character that make old photos so charming. (Note: This technique does not work with an inkjet printer.)

It's also a good idea to make copies of a whole batch of your photos at once. This way, you'll have them ready to go when you want to use this technique in the future, while also saving money, paper, and an extra trip to the copy shop. Use a self-serve copier at your local print shop so you can adjust the tones and contrast and experiment with different image sizes. Place a number of photos facedown directly on the glass of the copier. Cover them with a standard piece of copy paper and make a few copies of each collection of photos.

here's how it works:

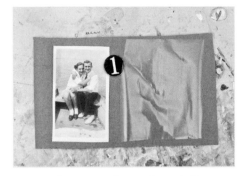

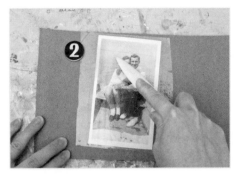

step one: Cut out one of your color-copied images, leaving a small border around all sides. Cut a slightly larger piece of contact paper and lay it down on a flat surface with the sticky side up. Place your copied image facedown on the piece of sticky contact paper. Just remember that the ink side and sticky side go together. This is important because at the end of the process the ink will stick to the contact paper.

step two: Rub the back of your image gently with your finger to adhere the two pieces together. Turn the image/contact paper "sandwich" face up and place on your flat working surface. Use the extra sticky edge of the bigger piece of contact paper to hold your "sandwich" in place. Now take your bone folder, fingernail, or a wooden spoon and strongly rub the front of the photo/contact paper pair together. The bone folder will firmly adhere the two surfaces together. More important, use the bone folder to remove any wrinkles or air bubbles you see under the surface.

step three: Carefully trim down the image, leaving only what you want to use in your collage. Place in a bowl of warm water and soak for at least 10 minutes. The longer it soaks, the easier the next step will be, but I don't recommend letting it soak longer than a few hours, as the ink may fade. I usually soak for about 10 minutes, which does the trick if you're in a rush. Soak longer if you are planning ahead.

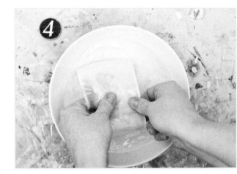

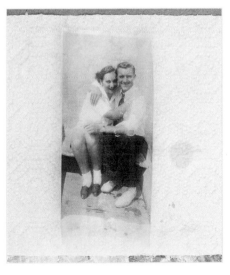

step four: Remove the image from the water. Using your fingers, gently rub the wet paper off the surface of the contact paper. It sometimes helps to do this step under running water or in the bowl. I also like to have a spray bottle of water to keep it wet as I remove the paper. As the paper peels away, you'll notice that the stickiness will be gone and the ink from your copy will remain on the contact paper. Watch your transferred image magically appear as you rub off the last of the paper! Dry off your new image transfer by gently blotting on a paper towel. You will now have a unique, transparent image ready to add to your artwork.

Turn the page to see how this transferred photograph gets incorporated into a final painting. You'll see it coming together step-by-step! This is the resulting transfer image.

Remember how the idea for this piece originally began? As seen in chapter 2, I pulled together some objects and this photograph to make a setup, which served as the original inspiration. Layering colors, objects, and collage materials alongside the found photograph helped me to plan the overall feeling of the painting.

In my sketchbook, I wrote down some notes about the couple in the found photograph, scribbling down whatever came to mind while looking at the setup and picture. The writing process helps me to learn more about them and get ideas flowing before I begin to paint out the story I've imagined. I imagined the couple in the photograph to be on their honeymoon in Maine in the summertime. They just look so happy to be together, so I decided to paint their story with a vibrant, summery color palette. Once I've prepared my notes, I'll begin to plan out the composition of the painting. At this point, I'll just place the transfer in the center of the piece as I work around it on the border of the painting.

I'll continue working on the border and then I'll start to test out collage material or paint colors to use behind the transfer. To do this I'll lift the transfer up and down while holding one edge to keep it in place on the board. Sometimes this takes some time and testing to get the image how I want it to look. Working with the different layers can be tricky, so it's important not to glue down the transfer right away. Once the background of the photo looks the way I want it to, I'll glue the image transfer to the board with gel medium.

To glue down the image, I use my gel medium on the board and then on the back of the transfer. To ensure that the image will lay flat with no bubbles, be sure that you paint on the gel medium in even coats. As I press the image down to the board, I am ready with another larger brush and more gel medium to go on top of the image to make sure it lays flat and sticks well. At this point I'll continue with the rest of the painting. See the final piece on page 123.

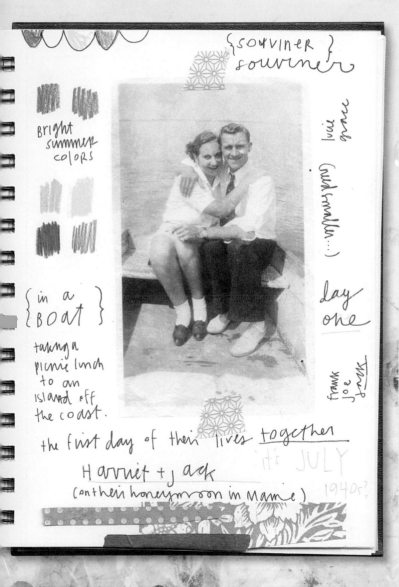

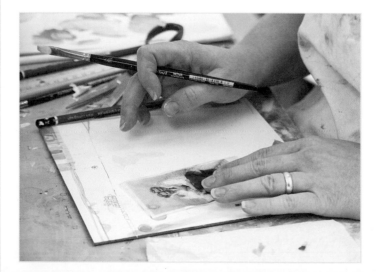

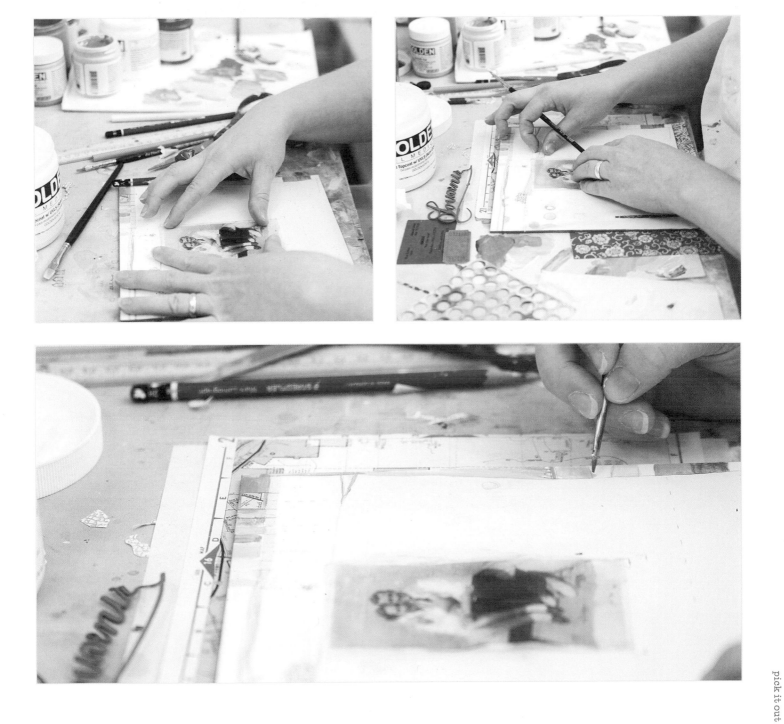

Have fun with image transfers! For the artwork at left, the image transfer process is used a little bit differently.

- On the photocopier, I enlarged this original image of my grandmother's second-grade class photo.

- I cropped the image and cut out only the corner where my grandmother was sitting. See how I gave her "new" little striped socks when I painted the background behind the transfer?

Once you feel comfortable with this process, it will have endless possibilities.

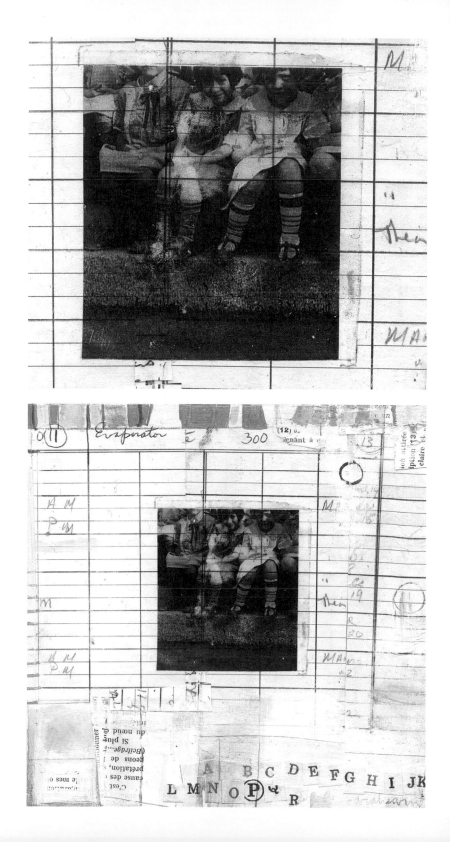

GUEST ARTISTS

Charity Rae and Heather L. Murphy
> *collections and collage*

CHARITY RAE is a dear friend who does fascinating and unique assemblage work. I asked her to share a bit about her process and unique "sketchbook." She's also a collector and like me, uses her collections in her artwork. But her collections are so unique! Instead of being found within pages of a sketchbook, Charity's assemblage ideas abide in drawers. In these drawers, one will find all manner of treasure and trash, relic and remnant—things from the sea, shell, sand, urchin; bones of bird, fish, shrew; insects; rusted metal scraps; clay and stone; paper, pieces of book pages, maps; seeds; wood; tiny jars, vials, and vessels; old photographs; cloth; twine.

The ideas for her work begin on a walk, when she might pause to retrieve a tiny feather from a lawn, an oddly shaped piece of metal from a crack in the sidewalk. The ideas are discovered at secondhand shops, forgotten memories found. The ideas lie quietly; bones wrapped in cotton, bees and moth wings in a box, awaiting their place.

Often when starting a piece, she will choose a character or a setting, a figure from an old photograph, a picture of home. After sifting through elements from her drawers, setting aside those that resonate at that moment, she begins fabricating a story, placing objects together with special attention to color, shape, and texture, all the while weaving in significance and meaning through use of symbolic objects. She often does not know the story herself as she begins, but rather she watches it unfold through the conversation formed between the objects and images.

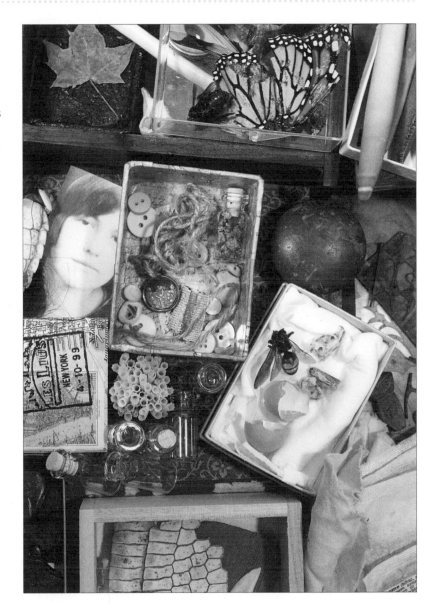

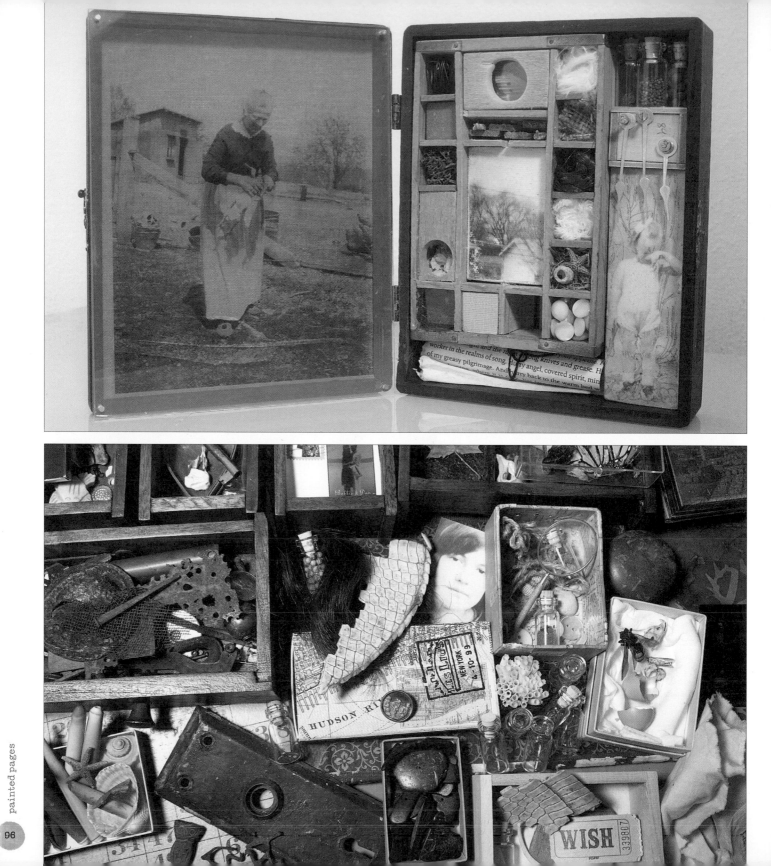

HEATHER L. MURPHY is a graphic designer and artist living in Charlotte, North Carolina, where she designs one-of-a-kind websites and creates mixed-media paintings. I especially love the layered collaged books Heather makes, and I asked if she'd tell us a little about how the books help her overall creative process. She said that when choosing collage papers, she loves to work with mostly vintage ones, along with some bits of new thrown in here and there. Her current favorites are ledger paper and transparencies that she adds to her sketchbooks. Heather says that Etsy.com has been a great resource for ledger papers, while she found other papers by rummaging at vintage shops and even junkyards. Her visual journals are a source of play and experimentation, a space to gather bits and pieces of inspiration and document her days. When she finds the blank canvas intimidating, moving to her visual journal usually helps her to take that pressure off and allows the space for her creativity to flow.

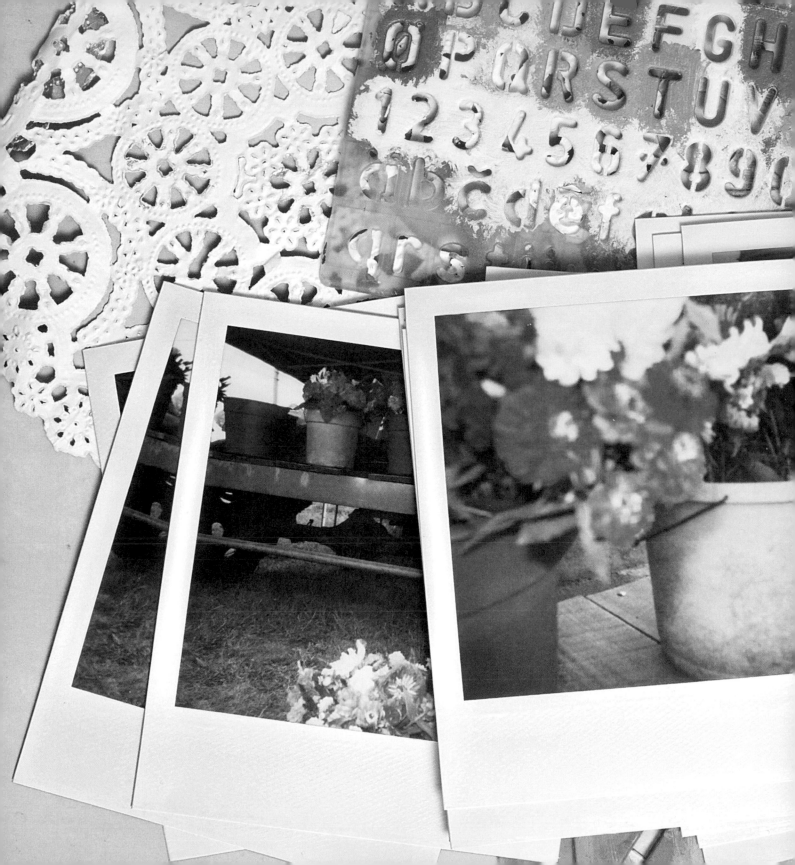

chapter five:
work it out

creative time and space ›

In the previous chapters, you've seen lots of ideas, examples, and ways of working with mixed media. From setting up an inspiring workspace to detailing specific techniques, I hope you've found some inspiration on these pages. At this point, maybe you've simply felt compelled to dust off your sketchbook, or perhaps you're ready to dive in and start your own mixed-media painting. But before you run off to your studio, I have one last how-to to share with you. In this final chapter, we will review the whole process of creating a painting from start to finish. On the next few pages, you'll see how one of my paintings evolves, from the first spark of an idea to the final brushstroke. Think of this as "a day in the life of a painting." You'll get a little peek behind the scenes—a view into my creative routine and a glimpse into my everyday life as a working artist. Perhaps it will help you to visualize how you might be able to incorporate a simple art routine in your everyday life.

finding your rhythm

When I work, each painting's process is a little different. For example, a painting made under a deadline for a specific show is bound to have a different evolution than one that is made just for fun on its own schedule.

Sometimes a painting will take a great deal of time, needing a lot of prep work, such as sketches and research. A painting such as this will take at least a few full days of nonstop work to complete, while others might immediately pop into my head spontaneously with a spark of creativity. When this creative spark strikes, it will send me running right off to the studio. These spontaneous paintings come fast and furiously. It's as if they can't be stopped and need to find their way out of my head and onto the canvas. Time will pass by unnoticed, I'll forget to break to eat lunch, and I'll be blissfully working away in my own little world. In reality, these idyllic creative moments don't always come easily while balancing work, family, and the business side of art. It's also because this type of creative "luck" does not naturally happen often. Creativity constantly ebbs and flows. Some days you may feel more creative than other days; more important, some times of the day might have you feeling more productive than others. Early morning is best for my energy and creative juices to flow, but perhaps you are a night owl and will just get going when it's late. No matter what

time of day suits you best, recognizing "your time" and taking advantage of it whenever possible is the key. A painting I might force myself to finish in the late afternoon never turns out how I would like it to. I've learned to be a very good listener when it comes to my inner creative clock.

It's not only important to find your best "creative time," but it's also essential to try to carve out a part of each day to be creative. Whether it be thirty minutes or a few hours, try to work (or play!) in your sketchbook or "creative space." That space will be different for everyone and also different depending on the day. By creative space, I mean both the physical and the mental space you will need to feel productive. The physical space just might be your kitchen table when everyone else in your house is still asleep. Finding your mental creative space could be a nice long walk with your sketchbook to clear your head from the clutter of the day and make room for your inspirations to flow freely.

Recently, I have looked back on my sketchbooks and paintings to surprisingly discover that some of my favorite works were created in the late spring and early summer. Not only is a daily creative routine important, but you too may find a certain season will bring you enhanced inspiration!

YOU MUST
GIVE BIRTH to
YOUR IMAGES

THEY ARE THE
FUTURE WAITING
TO BE BORN. -rilke

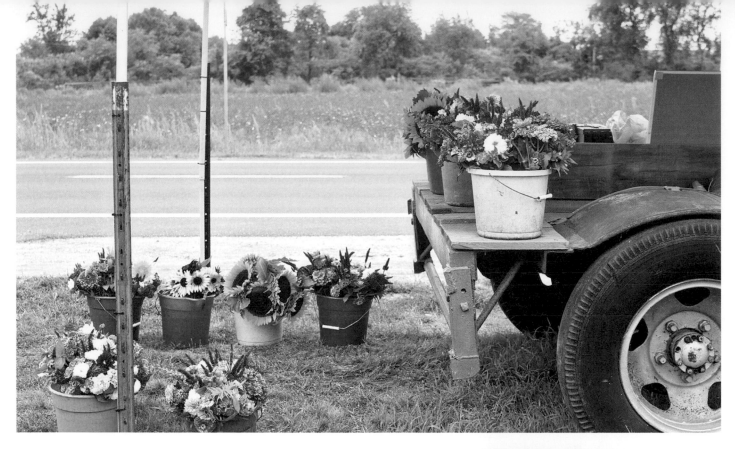

creative process: at the farm stand

The season that brings me the most inspiration is definitely summer! (See the summertime inspiration lists on pages 65 and 66.) As a child, summer meant long days playing by the seashore, while today, summer to me means long drives on winding back roads in the country. Along the way I'll stop at my favorite farm stands to pick up an ice cream cone, fresh vegetables, or bunches of in-season flowers. Recently a trip to one of the farm stands on a Sunday inspired a big painting.

See the creative process and a painting's progression, from early inspiration to the final piece, on the next few pages.

Taking pictures at the farm stand

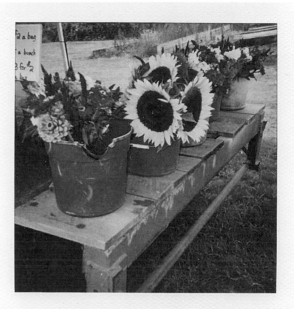

At the farm stand, I take a lot of Polaroid pictures to use in my sketchbook. My Polaroid camera is a favorite tool of mine; I often use it as part of my process. With the camera, I am able to capture my instant inspirations and ideas. The photos are then added to my sketchbooks to remember how things looked.

The colors of the flowers were just so stunning! The reds, oranges, and pops of pink felt so fresh and fun. These colorful blooms really made me want to go home and paint a big painting, so I bought two giant bouquets and did just that!

we stopped at
the perfect
farmstand
with summer flowers

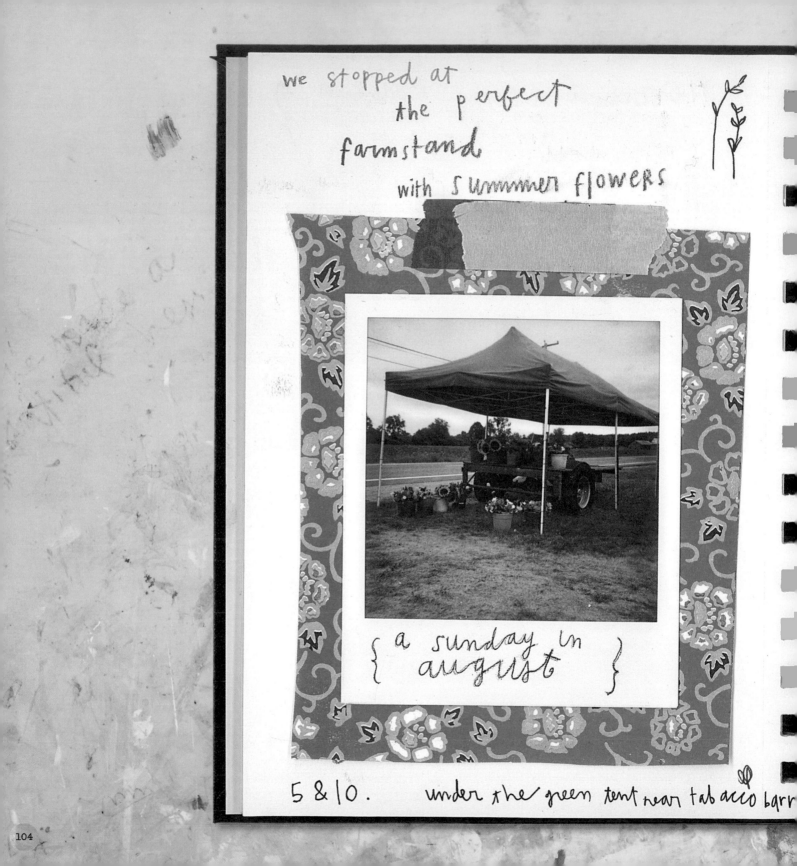

{ a sunday in august }

5 & 10. under the green tent near tabacco barn

a sunday (noon) in august

HUGE
BOUQUET is
{ only 5 dollars! }
so we bought 2 for our new house.

(lots of unexpected pinks)

5
6 4
7 3 practicing
1 2 petal
 shapes

Bright reds
+ oranges

{ the zinnias are my }
 favorite

perfect green
stems

farmstand flowers
make me happy

------- maplines dotted in red

{ use
rolls of
piano
paper }

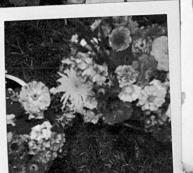

back in the studio:
starting a painting

Back in my studio, I work out my ideas for a painting and quickly record my inspiration in my sketchbook. Even small-scale doodles and sketches can help you warm up and build toward a larger piece.

Collage materials are gathered, ready to be included in the composition. It's helpful to have everything you might want to use in your painting in front of you, spread out within reach.

The red flowers in the bouquets remind me of the setup hanging on my chalkboard (see page 43). The flowers featured are also zinnias, and the setup informs my plan for the piece as I begin to paint.

To begin, I paint in the background with fields of bright colors that capture the late-summer feel of the day.

we stopped at
the perfec
farmstand
with summe

{ a sunday
august

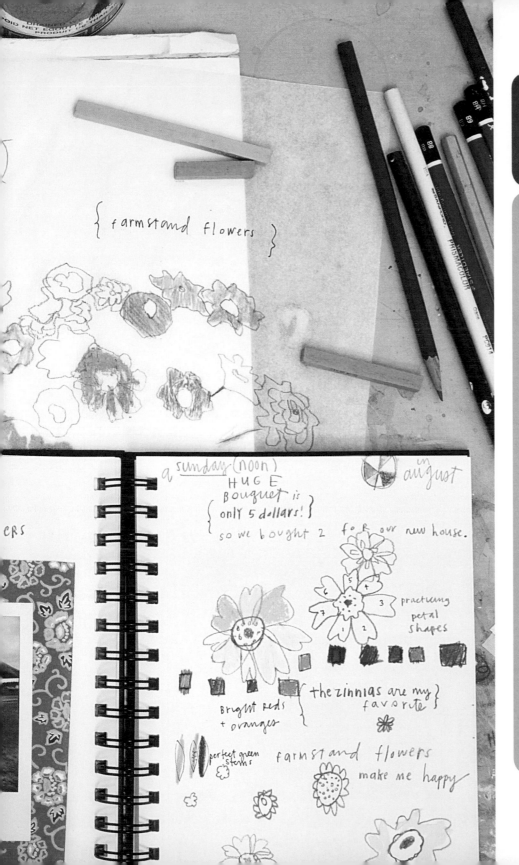

TIPS FOR WORKING

- Start with simple washes of color and quick outlines of patterns, which allow you to easily establish the emotion of a piece. In contrast, by focusing on fine details first, you can spend hours lost in one section of the painting, after which the initial emotional inspiration for the painting may fade.

- Once the groundwork for the painting is set, it's time to decide on placement of key elements of collage material. Focal elements tend to feel best when they are offset from perfect center. Play around with the placement of collage elements before adhering them to your painting to be sure they satisfy your artistic eye.

- Trust your instincts and don't overanalyze.

- Relax and let the process unfold naturally.

- Try not to worry about the final outcome.

- Let the painting lead you.

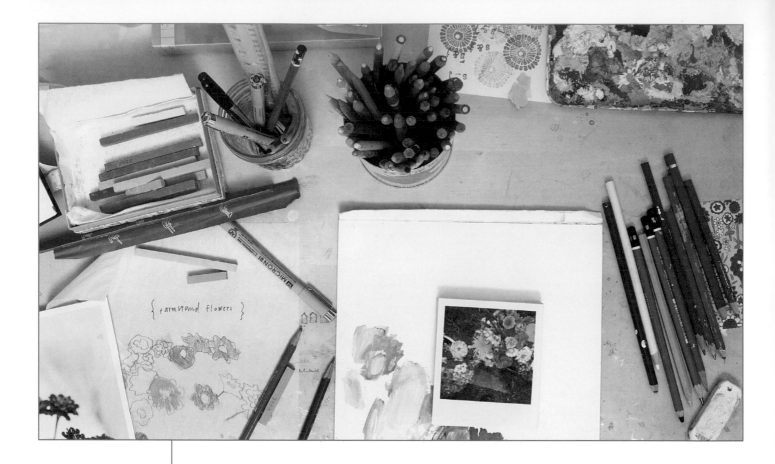

The colors of the flowers are used as inspiration for my palette.

I start with washes of the main colors for the painting and work quickly.

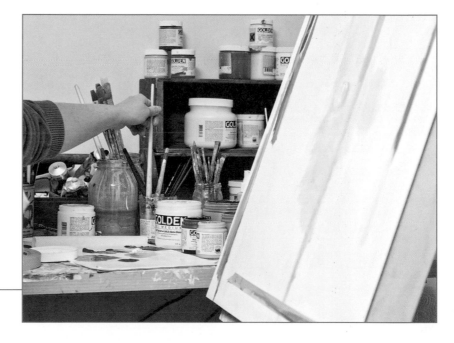

Use masking or **artist tape** to mask off parts of the painting or to make straight lines. The tape won't leave a residue on the painting and **peels off easily.**

Once the **background** is laid out, I add in some details with pencil and **colored pencil.**

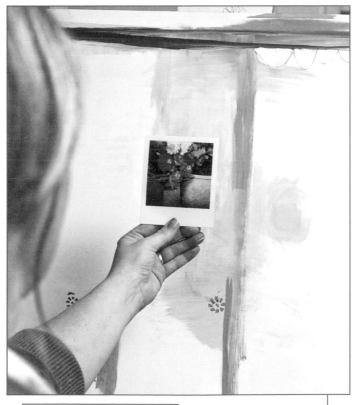

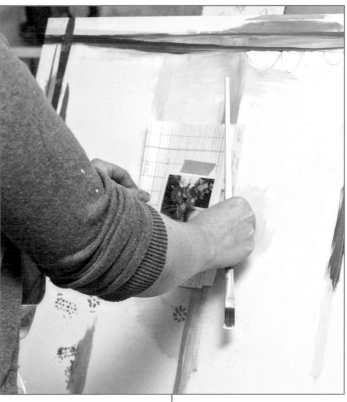

I look to **favorite Polaroid images** for **color ideas** as I work on the painting.

I love how the **Polaroids** turn out, so rather than just using them solely for inspiration, I spontaneously decide to use a transfer of one as the **main collage element** in the painting.

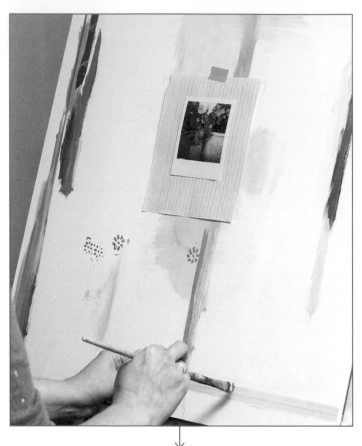

I tape the photograph onto a piece of graph paper and use it as a placeholder as I work.

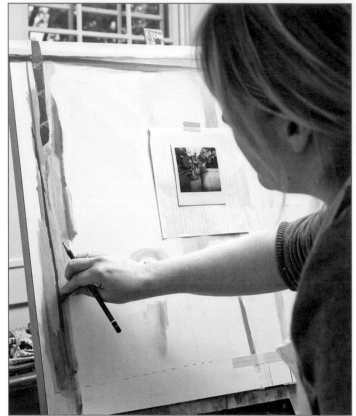

Drawing with red chalk pastel directly on the board adds a pop of color.

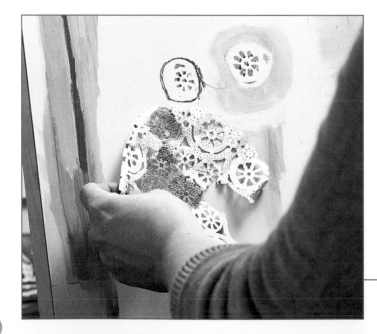

Little shapes reminiscent of flowers are stenciled onto the painting with a doily.

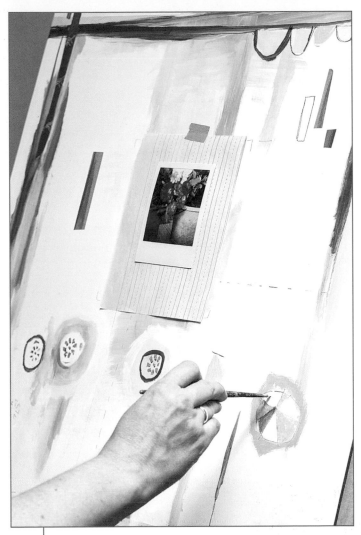

I **continue to paint** until I am satisfied with the first layer of paint. At this point, I begin **adding small details**.

The rectangular shapes from the **piano-roll paper** are repeated and enlarged in the painting.

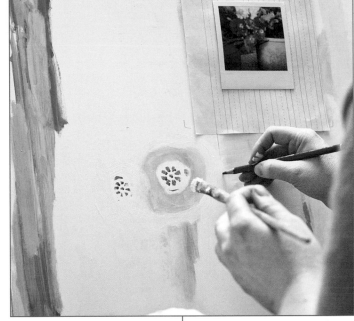

Sometimes I end up with a **paintbrush** in one hand and **a pencil** in the other!

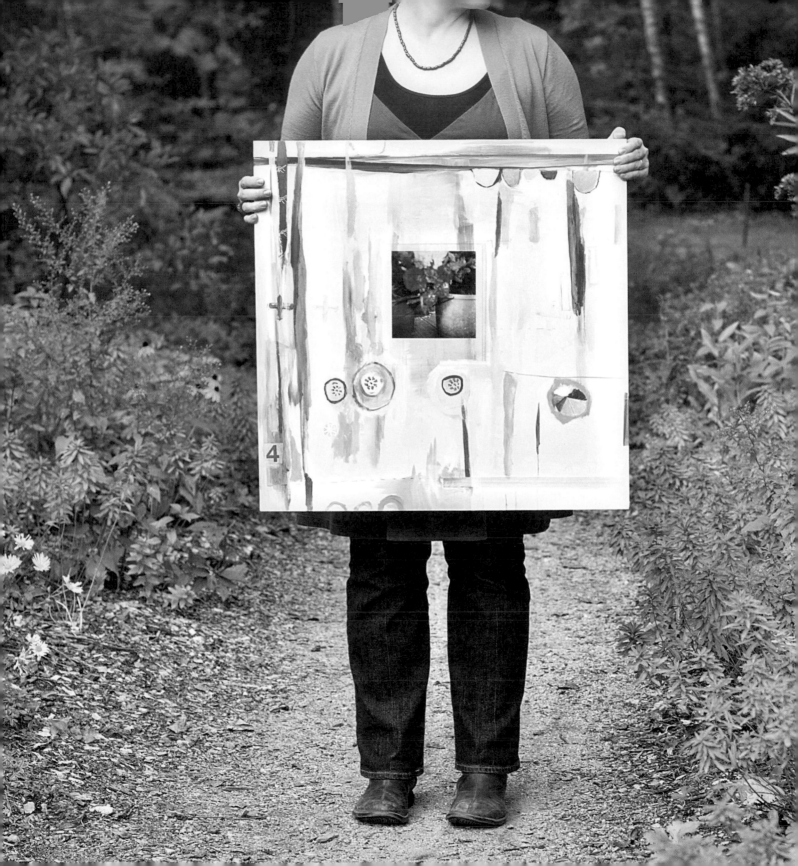

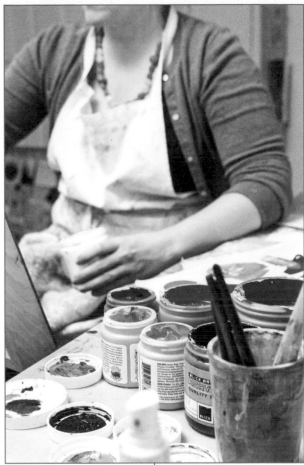

I continue to work on this painting for
a few days until it feels finished.
As you can see, a special experience on
a late summer's day, collage elements, and
specific techniques are merged in this finished piece.

* * *

Together these steps make up the important elements
of the creative process, start to finish.

Stephanie Levy, Betsy Thompson, and Jennifer Cooke

> *three artists share their work process from start to finish*

In this "start-to-finish" chapter, I thought it would be fitting to share with you some other artists' ways of working from start to finish. Here you'll see the work of three artist friends: Stephanie Levy, Betsy Thompson, and Jennifer Cooke. Each of these guest artists will take us from their sketchbooks and spark of inspiration to show us a final, finished work of art.

STEPHANIE LEVY is an American artist and illustrator living in Germany with her husband and two little girls. She's a prolific artist who makes bright, colorful collages of papers and paint. For Stephanie, inspiration may appear at any time—for instance, when she's looking through a book or magazine, or even the IKEA catalog. Her sketchbook is the perfect place to quickly record these inspirational flashes before they disappear. If she's feeling stuck on a particular

piece or series, or she needs to brainstorm new ideas, she says it's great to take a break and warm up in her sketchbook to get into the flow again. Her sketchbook is a place where there are no rules and she is free to experiment with new ideas and materials. The private nature of a sketchbook makes it easier for her to put ideas on paper without worrying if they are perfect, realistic, or useful. Working in her sketchbook is great for dissolving creative inhibitions. She can close her book, forget about it, and come back to it again on another day. Her sketchbook is not about creating artistic masterpieces that stand alone; it is an ongoing, fluid work in progress that documents her flow of ideas.

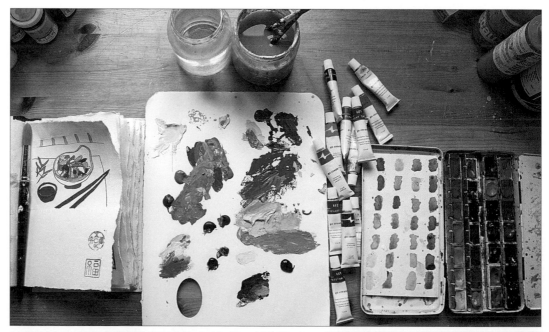

Stephanie's sketchbook and palette

Stephanie's finished collage

She uses various types of sketchbooks for different reasons. Simple notebooks with plain pages are fine for jotting down notes and quick ideas. When she is working with paints and collage, Stephanie enjoys using sketchbooks with thick, textured watercolor paper. However, she says that she has to be careful about choosing the most gorgeous sketchbook she can find. When the sketchbook itself is too beautiful, she says it can be a challenge to get past the "not wanting to mess things up" stage.

In Stephanie's collage method of working, she starts by making ink drawings of interiors, still lives, and domestic objects she finds inspiring. Often she makes the drawings on other papers first and combines these with various materials in her sketchbook. She loves collecting and incorporating various textured, patterned papers from all over the world and nontraditional fine-art media. Sometimes she even adds string, stars, and kitschy materials to the collages to give them an offbeat, playful touch. Acrylic and watercolor paints are her favorite ways to add color.

BETSY THOMPSON lives on the coast of Maine with her husband and two daughters. A former educator, she is now a full-time artist and illustrator. She is inspired by parenthood, patterns in nature, organic shapes, vintage and contemporary children's book illustrations, mid-century modernism, the kitchen, expressionism, the concept of home, and her life by the sea. I asked her to tell us about her sketchbook and creative process. Here, Betsy shows us how one of her collages emerges from just a small doodle in one of her books.

Betsy says that her sketchbooks are full of contradictions.

They are full of detailed drawings and messy doodles.
They are organized and jumbled.
They are in black-and-white and in color.
They are tidy and smudged.
They are full of new ideas, old memories, and possibilities.

She has piles and shelves of sketchbooks and journals. How she's used them has evolved over time, but now she tends to keep three different types: sketchbooks full of detailed drawings, quick doodles, and art ideas; journals for writing ideas and studio to-do lists; and inspiration books for photos, images, postcards, magazine clippings, notes to herself, and more doodles and drawings.

The drawings in her sketchbooks serve as inspirations for her full-color collages. She doesn't work in her sketchbook every day, but she usually has at least two different books tucked into her bag so that she can jot down an idea and do a quick sketch. Any writing she does in her sketchbook is usually related to the use of color, materials, a list of subject matter that she may want to explore further, ideas for gallery shows, possible titles for specific pieces, and the names of inspiring artists and illustrators. She draws from nature, her imagination, photos, and books. Betsy says she finds inspiration everywhere ... in libraries, galleries, at home, the garden, the beach, and around town. She then tries to capture as much of it as she can in her sketchbooks to bring back to her studio.

Farmers Market

radish
carrot
scallions
lettuce
tomatoes

artichoke
asparagus
green beans
broccoli

eggplant
corn
garlic
snow peas

Animal Feet

Tracks

kneeling and
mpt bird

seagull

lobster boat

surrounded by lucky

village harbor

music sheet

summer fruit

cherries
peaches
plums
nectarines
raspberries
blueberries
strawberries
blackberries
melons
figs
redcurrants
apricots
pears
black currants

schrodic tracks
(black bear?)

moose
deer
crows
ducks
terns

gulls
bald eagle
fox (red)
bobcat
skunk
weasels
mink

mice
shrew
hares
muskrat
otters

porcupines
beaver
woodchuck
chipmunks
squirrels

mussels
barnacles

junco
sparrow
starer

Schrodic
Dreamscape

JENNIFER COOKE is an artist and designer who lives in western Massachusetts with two cats and a wildlife biologist husband. She has been designing T-shirts for over a decade under the label Raeburn Ink. Jennifer also happens to be my neighbor and good friend. We get together regularly to talk about art and upcoming projects over tea, which helps us both remain inspired and motivated with our own work. I have loved learning about Jennifer's creative process, and I am so happy to share with you a glimpse into how she turns her inspirations from her sketchbook into patterns for her products.

Jennifer recently traveled to northern India, where she visited a host of historic sites—mostly forts and temples. She took a lot of pictures while she was there and used many of them as departure points for drawings that would eventually develop into textile patterns. She did all of her drawings in her sketchbook after she had returned home. This particular photo (opposite page, top) is an example of an architectural motif she saw a lot: scalloped relief patterns carved into stone walls and archways. The scalloped patterns seemed cloudlike to her, and she ended up creating a drawing of rows of cloudlike shapes (opposite page, bottom). She then turned this drawing into a repeat pattern for textiles (which she suitably named *Cloudlets*) and sewed scarves and tote bags (at right) from the fabric.

She often uses sketchbooks in this way—to expand on a visual idea that interests her. Sometimes, as she has done in with the *Cloudlets* print, Jennifer will create a fairly finished design in her sketchbook. Often, though, she will scan bits of sketches from her book into the computer and manipulate them in Photoshop to create finished designs.

A photograph that Jennifer took in India (top) inspires doodles in her sketchbook (below).

chapter six:
gallery

july sky
acrylic/mixed media on board
5" x 5" (12.7 x 12.7 cm)
See how this piece was started using the "two-minute prompts" exercise on page 18.

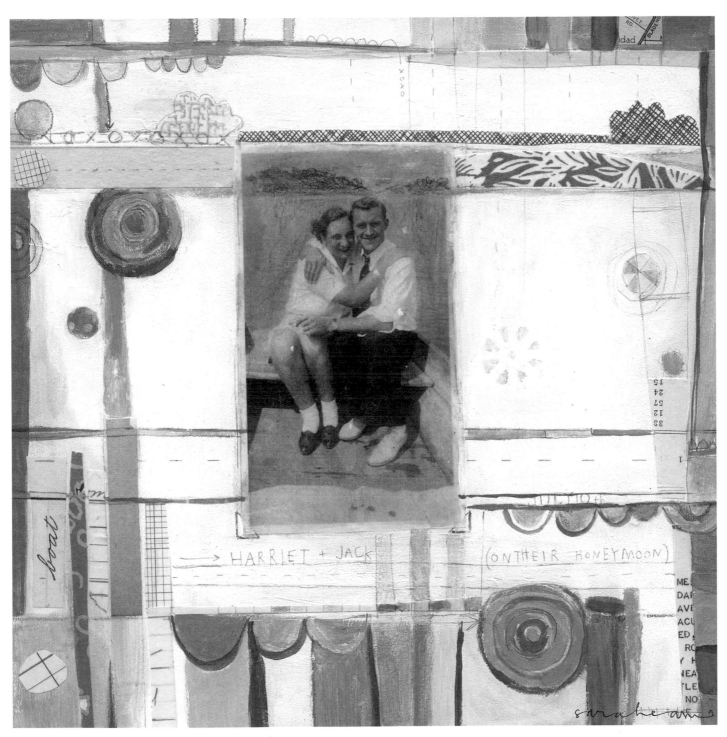

Harriet and Jack (on their honeymoon)
acrylic/mixed media/image transfer on board
8" x 8" (20.3 x 20.3 cm)
See how this piece began on page 90.

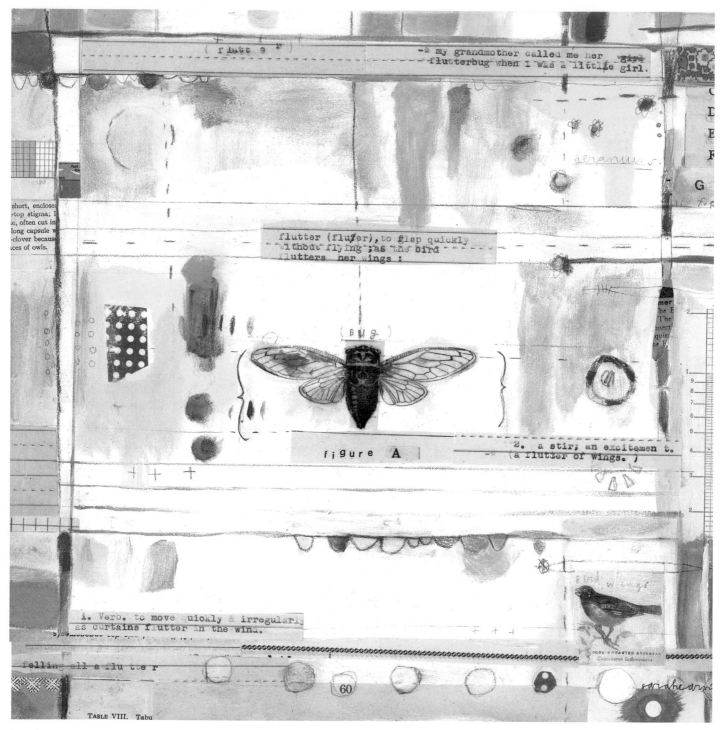

flutterbug
acrylic/mixed media/image transfer on board
12" X 12" (30.5 X 30.5 cm)

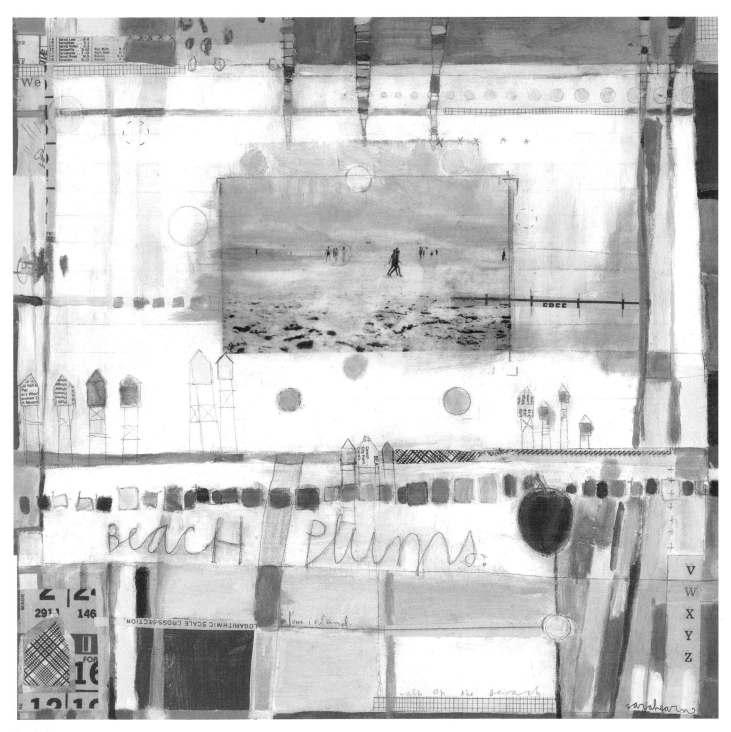

beach plums
acrylic/mixed media/image transfer on board
12" x 12" (30.5 x 30.5 cm)

about the photographer

Thea Coughlin is a photographer in Albany, New York, whose whimsical approach to photography allows her to effortlessly connect with her clients and capture what is unique in each of them. www.theacoughlin.com

our collaboration

While brainstorming this book in its early stages, I knew that one of the most important aspects would be the photography. I wanted to work with a photographer who shared my vision and aesthetic, who was easygoing yet hardworking, and someone whom I felt I could truly collaborate with. I feel incredibly lucky that I found that person, and more, in Thea Coughlin. Thea and I had met before, when she came to do a photo shoot of me in my studio. Her images from that session were so dreamy and beautiful, it made me see my space and myself in a whole new way.

Working with her on our book shoots was a dream come true. I looked forward to our days together, and even though each shoot required hard work from both of us, we had a lot of fun, quite often feeling as if the time had just flown right by. Thea's eye for detail is spot-on, and her sense of color, light, and composition is just remarkable.

I absolutely trusted her as my partner in this project; it became a perfect collaboration of both of our talents.

Since we each have young children at home, squeezing in full-day shoots together was not always the easiest task. Quite often there was a baby sleeping among Thea's photo equipment or a little boy playing with his cars as we worked, but we pulled it off and managed to have a great deal of fun in the process. I am awfully proud of what we accomplished together.

Thank you, dear Thea, for everything. This book would not be what it is if it were not for your dedication and enthusiasm. Your sweetness shines though all that you do. You are a true artist.

contributors

Charity Rae Burger
www.flickr.com/photos/charityrae

Christine Chitnis
www.christinechitnis.com

Jennifer Cooke
www.raeburnink.com

Heather Smith Jones
www.heathersmithjones.com

Stephanie Levy
www.stephanielevy.com

Heather L. Murphy
www.heatherlmurphy.com

Shanna Murray
www.shannamurray.com

Kari Chapin Nixon
www.karichapin.com

Lucie Summers
www.summersville.etsy.com

Betsy Thompson
www.betsythompson-studio.com

Thea taking a picture of me, taking a picture
Photo by five-year-old Trey Coughlin

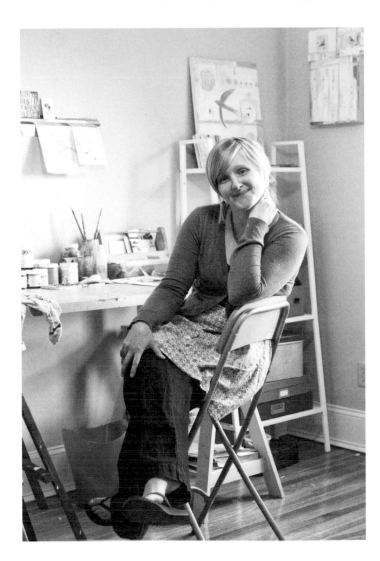

about the author

Sarah Ahearn Bellemare is a mixed-media painter who lives in western Massachusetts with her ecologist husband and brand-new baby girl. She's been an artist for as long as she can remember and she feels extremely fortunate that her passion and career have merged and that being an artist is now her job. Sarah's mixed-media paintings are layered with found images, fragments of text from old books, and pieces of vintage maps. These ephemera become the fabric and focus of her whimsical paintings, many of which are inspired by her childhood memories of time spent by the seashore on Cape Cod. Sarah has taught art to many students in a variety of settings ranging from art camps to museums, teaching students age three to sixty-three. Her work can be seen at galleries and art fairs as well as on her website www.sarahearn.com.

acknowledgments

Thank you to Mary Ann Hall for reaching out to me and supporting my vision for this book. Your patience, help, and understanding made what sometimes felt like a daunting process possible. Many thanks go to all at Quarry Books for bringing my artistic visions together into a tangible book.

To Elizabeth: Thank you for the magic of Squam; it helped bring this book to light.

To the lovely ladies who contributed—many thanks for sharing your own art, which made a wonderful addition to this book.

To Diana for your brainstorming and early nudges of "you can do it!"

To Jen for your super-duper styling assistance, advice, and friendship.

To friends and family for your understanding and encouragement during the crazy time of my "whole book thing."

Mom, Dad, and Heather, thank you for believing in me no matter what, and for always supporting my creative endeavors even if you don't always understand them. Extra-special thanks to my mom, who was here almost every day near the final deadlines to help out with Ada while I typed. We are so lucky.

Ada Maeve, thank you for being born into this world so conveniently between book deadlines and for being such a good sleeper. You are the sweetest little peanut; I cannot wait until the time when we can make messes together in the studio.

Lastly, to Jesse, my incredible husband, biggest supporter, and partner in crime. Thank you for helping me through the sleep-deprived patches of worry. I could not have made this book without your endless encouragement, insights, and love.

two-minute prompts

For instructions on using these prompts, see the warm-up activity on pages 18–19. Photocopy prompts onto cardstock and cut apart.

*
rip out a page in a book and use a piece for collage

*
close your eyes and paint or draw on your surface (no peeking!)

*
use colored pencils directly on your surface

*
layer paint with collage

*
paint with your finger!

*
use a paint color that you don't like (you just may change your mind!)

*
paint lines, shapes, or dots with a tiny brush

*
write a few words with the rub-on letters

*
paint only with white paint

*
try soft pastels, smudge, and use gel medium

*
use only a pencil. scribble, and draw shapes. try different leads

*
sign your name somewhere on the piece. you are an artist!

*
paint with a big brush. try a wash of color

*
use rubber stamps to write one word. use a thin layer of paint as your "ink." stamp the first word that comes into your head and use it as a theme for your painting

*
collage with gel medium (no paint)

*
stencil with a doily or another "nonstencil" type of item